Grandpa and the Library

How Charles White Learned to Paint

C. Ian White

The Museum of Modern Art, New York

Dad, where are we going?

We're going to the library to see a mural painted
by your Grandpa Charles.

Exposition Park Dr. Mary McLeod Bethune Regional Branch
LOS ANGELES PUBLIC LIBRARY

Gordon, look! The words on the mural say, "Love, hope, dignity, and education." This is what he believed in, and this is what he wanted to share in his art.

How did Grandpa Charles become an artist?
Did he start when he was very young? As young as me?

Even younger, Gordon. It started when Charles—my father—
was about to turn five years old.

Your Great-Grandma Marsh worked long days cleaning houses, and Charles was too old to go to work with her. There were no preschools or daycare centers when your grandpa was five, and babysitters were too expensive.

So she took him to the Chicago Public Library each morning with his lunch box. She reminded him to be polite, and then she went to work.

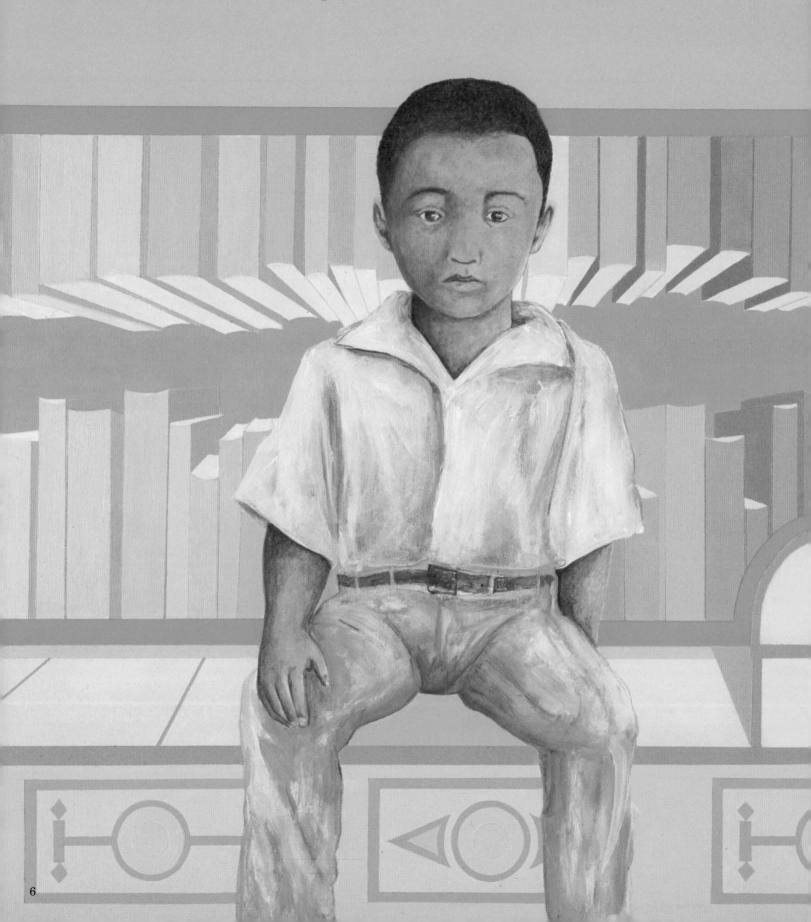

She left him at the library all day? Alone?

Yes, all day. Great-Grandma Marsh assured the librarian that her son was a very well-mannered young man who would sit nicely in the corner with his books.

And he did?

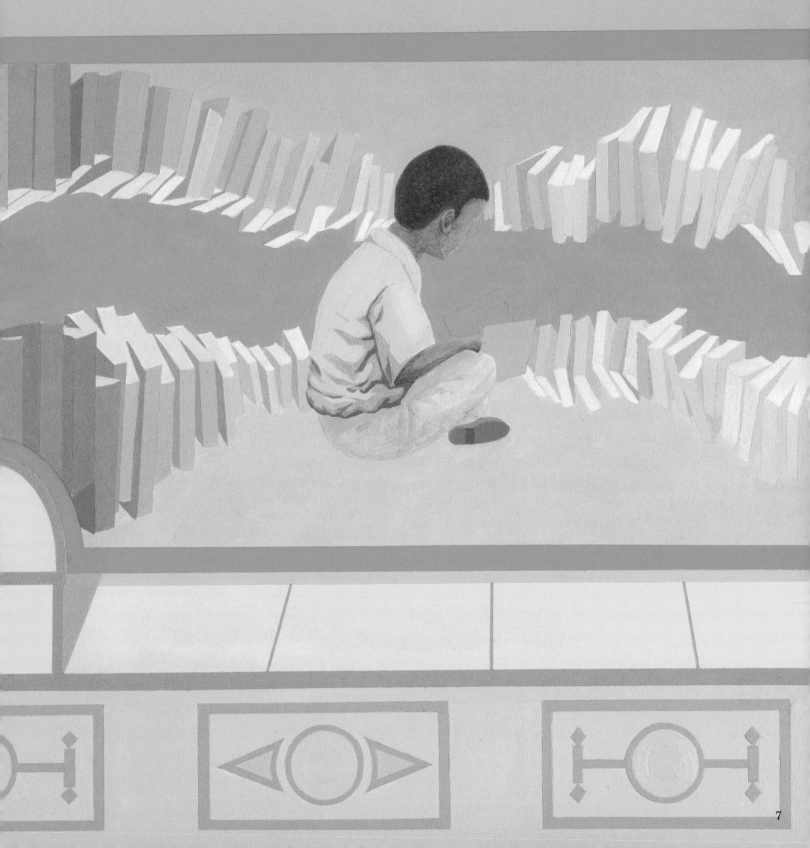

Yes, he did. Charles liked the library. It was quiet, like home. The librarians were strict, like his mother. He couldn't read yet, but they gave him picture books about places he'd never been and the people who lived there.

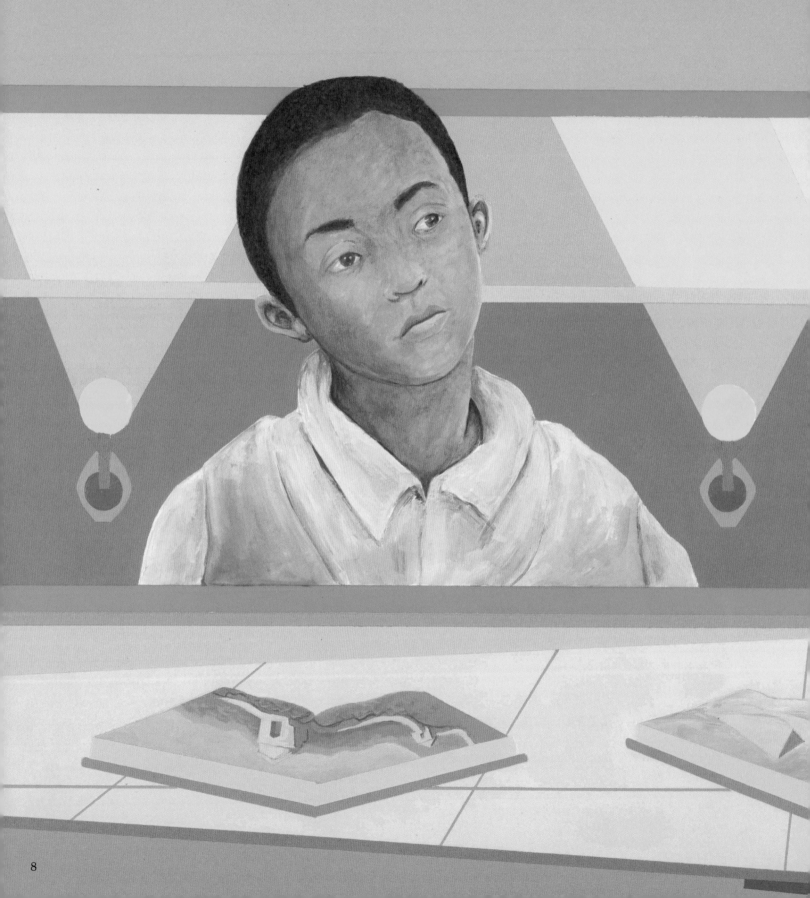

He looked at the books and watched the clock on the wall, waiting for the big hand to reach twelve and the little hand to reach six. That was when Great-Grandma Marsh would come back.

THE WORLD IS FOUNDED ON THOUGHTS
AND IDEAS. NOT ON COTTON OR IRON
+ + + + + EMERSON + + + + +

Your grandpa drew the shapes and figures he had seen in the books on pieces of scrap paper that his mother saved for him. He loved to draw! He drew landscapes like the ones in his books, and people like the ones he had seen in magazines.

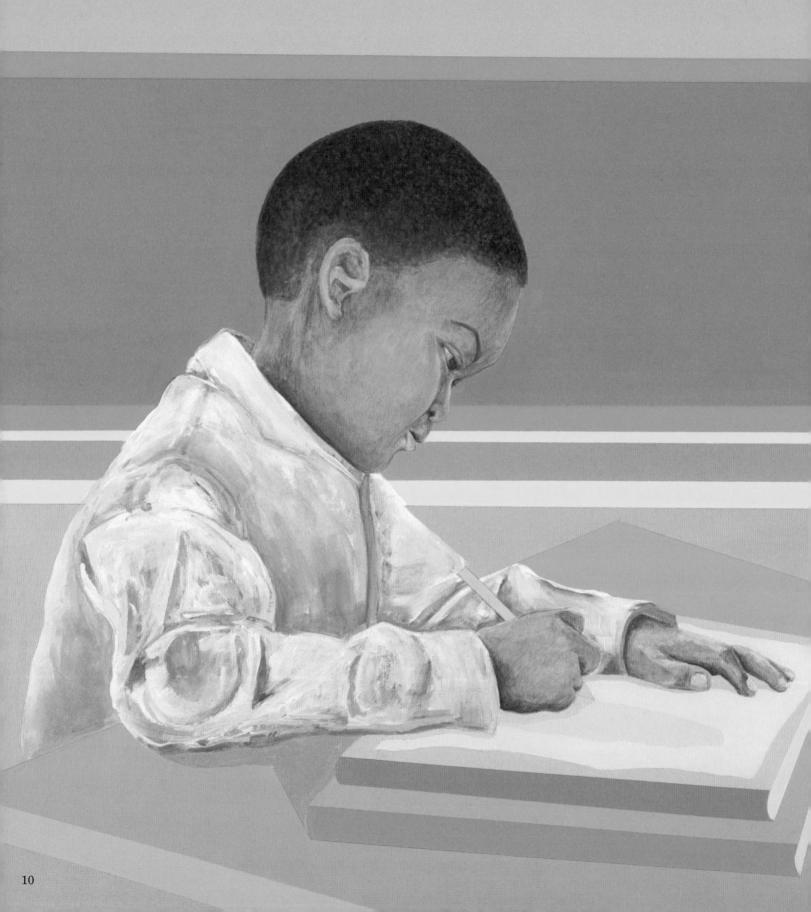

He missed his mother when she was at work, and he wished he could draw her, too. He thought about her cleaning windows and dusting furniture, moving quickly through the rooms of big houses. She could make a silver tray shine like a mirror.

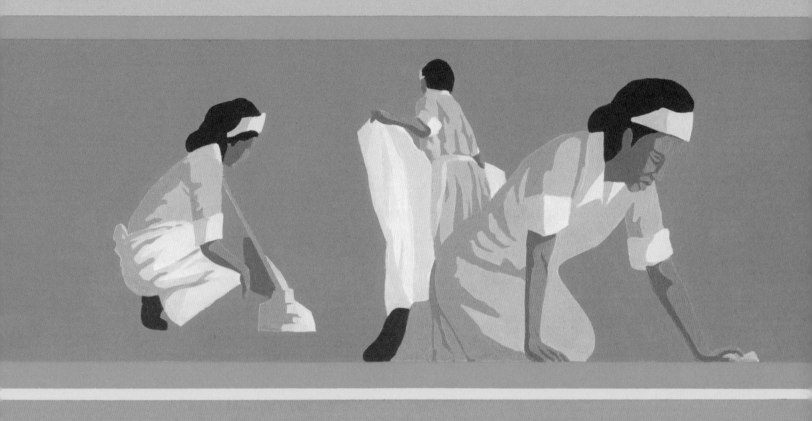

Great-Grandma Marsh began to take Charles to the Art Institute of Chicago on Saturdays. There they walked through rooms filled with paintings by great masters.

What are great masters?

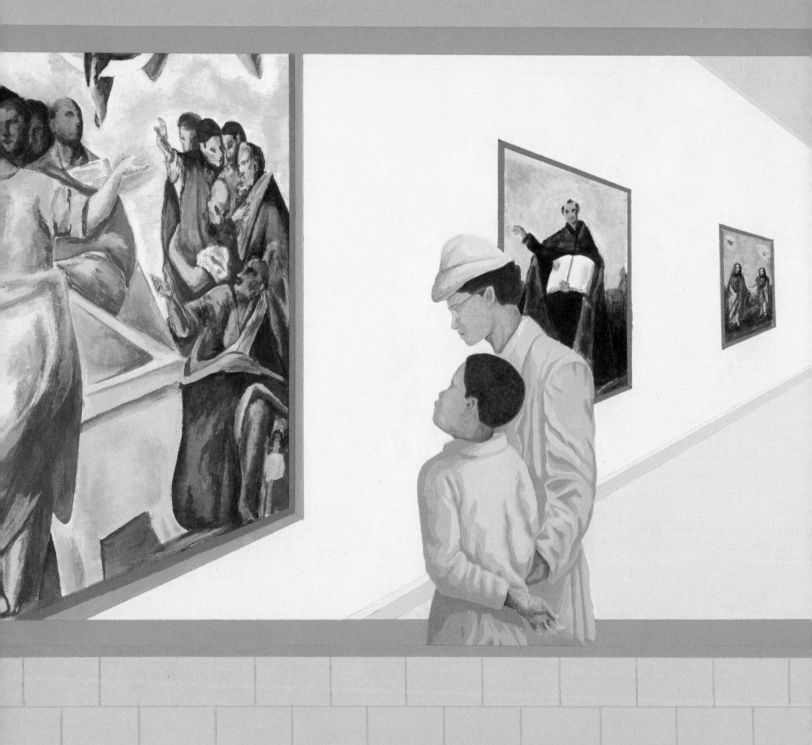

Great masters are artists who worked very hard for a long time to be very good at what they did. From looking at their art, Charles learned that there were many things to paint and many ways to paint them.

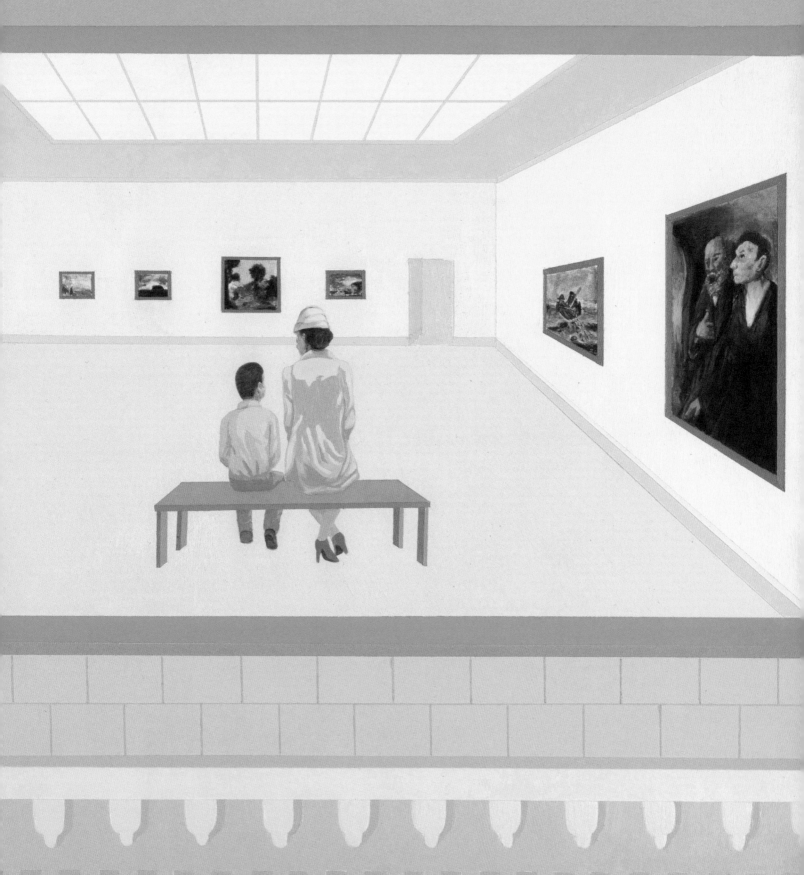

The following year, Charles started school and learned to read.
In the afternoons, when school was over, he went back to the library
and read every book he could.

Did he stop drawing?

No, he got better at it! Now he enjoyed drawing the different people
he passed on the streets of Chicago as he walked home.

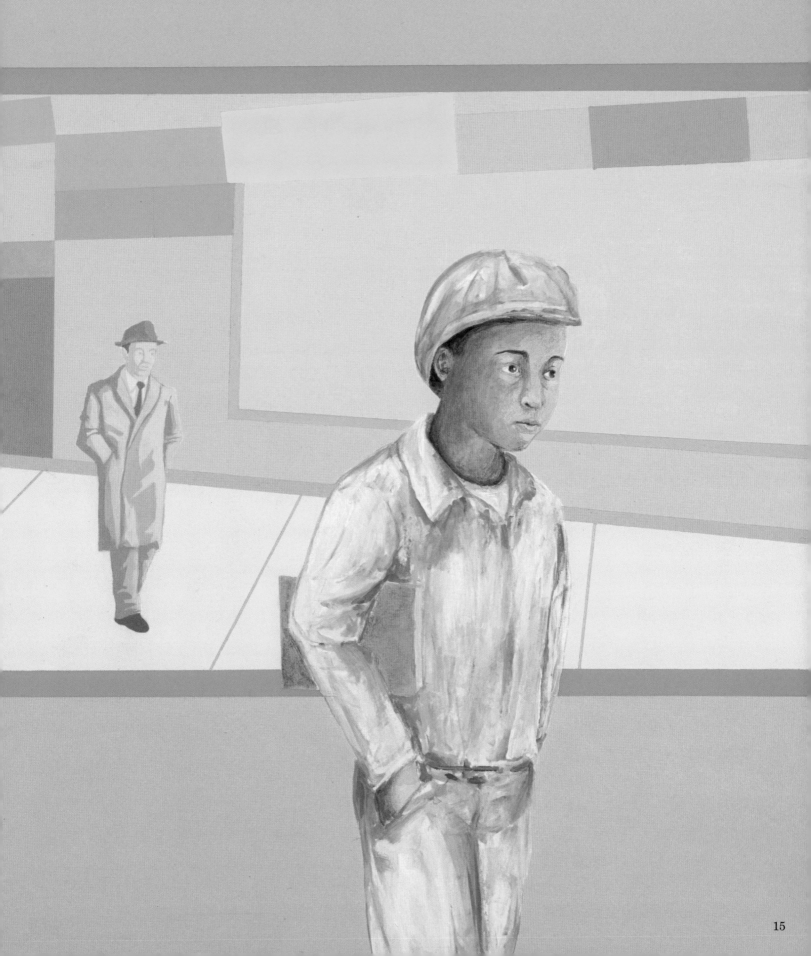

When Charles was seven, Great-Grandma Marsh gave him a set of oil paints for Christmas. Oh, he was excited! He had never painted before!

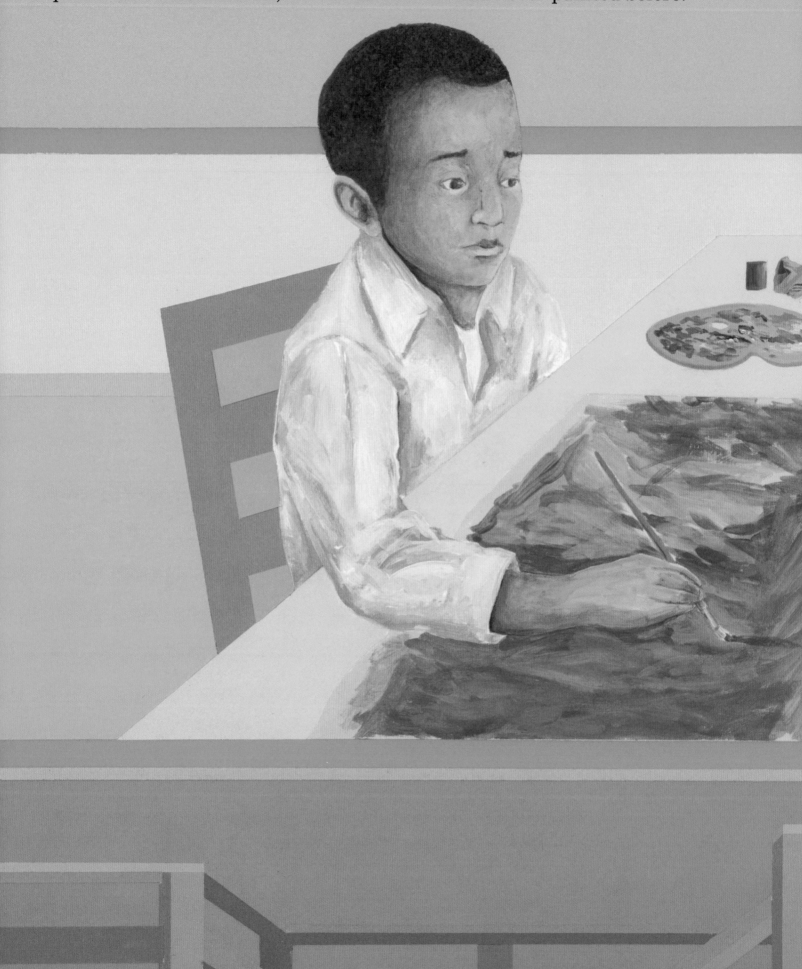

He tried them out but grew impatient. He was confused by the materials that came with the set—the stand oil and turpentine. The paint was very different from the pencils he was used to.

Did he give up?

Oh, no!

One day, when he was walking home past the Art Institute, on Michigan Avenue, he saw art students in the park. They were painting landscape pictures, and they had paints just like his. He overheard one of them say that they would be painting in the park all week.

So he went back to the park the next day. He watched the students carefully and observed that they mixed a little stand oil and turpentine in a container and then added the paint. Every day that week he watched them work, and every day he learned a little more.

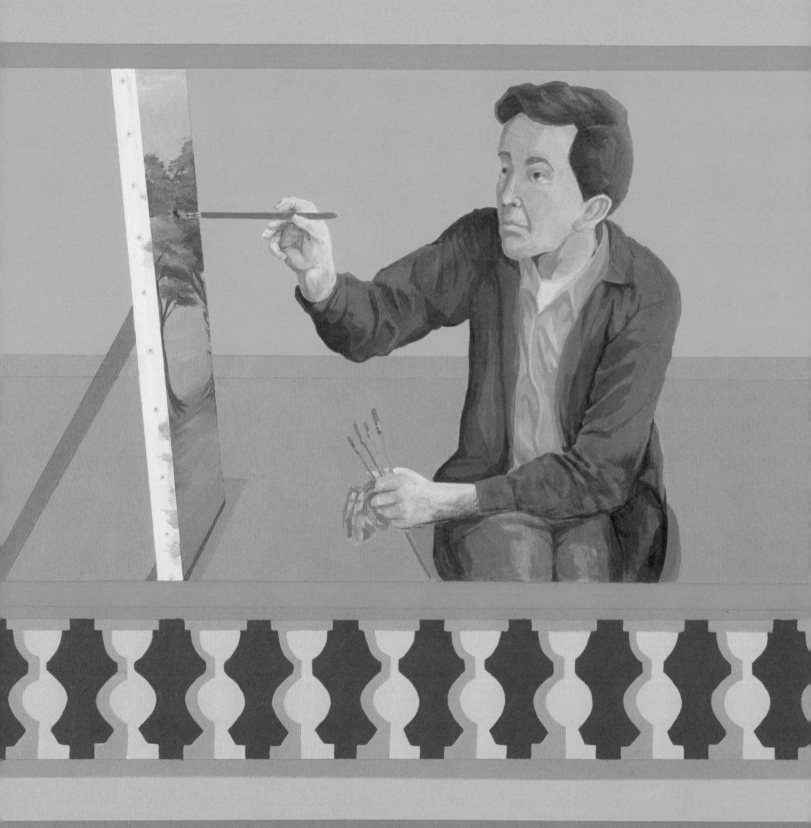

Charles imitated them with his paint set, using cardboard cut from boxes. But the paint soaked right into the cardboard—it wasn't like the material the students used.

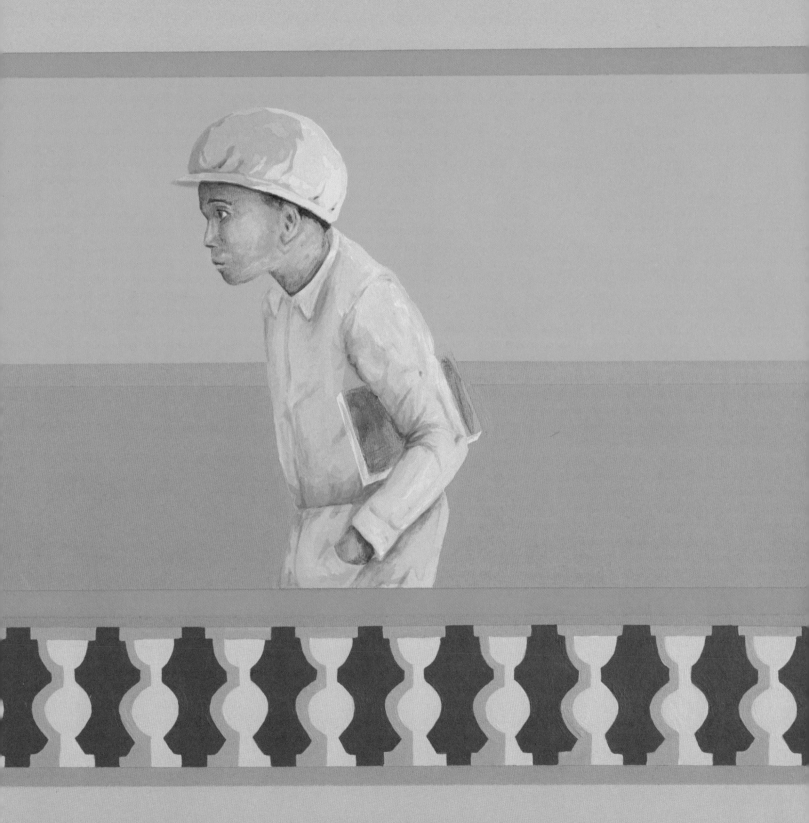

At home, Charles noticed that the window shade in Great-Grandma Marsh's living room looked a bit like that material. He cut out a nice big piece and painted a landscape on it.

He was an artist!

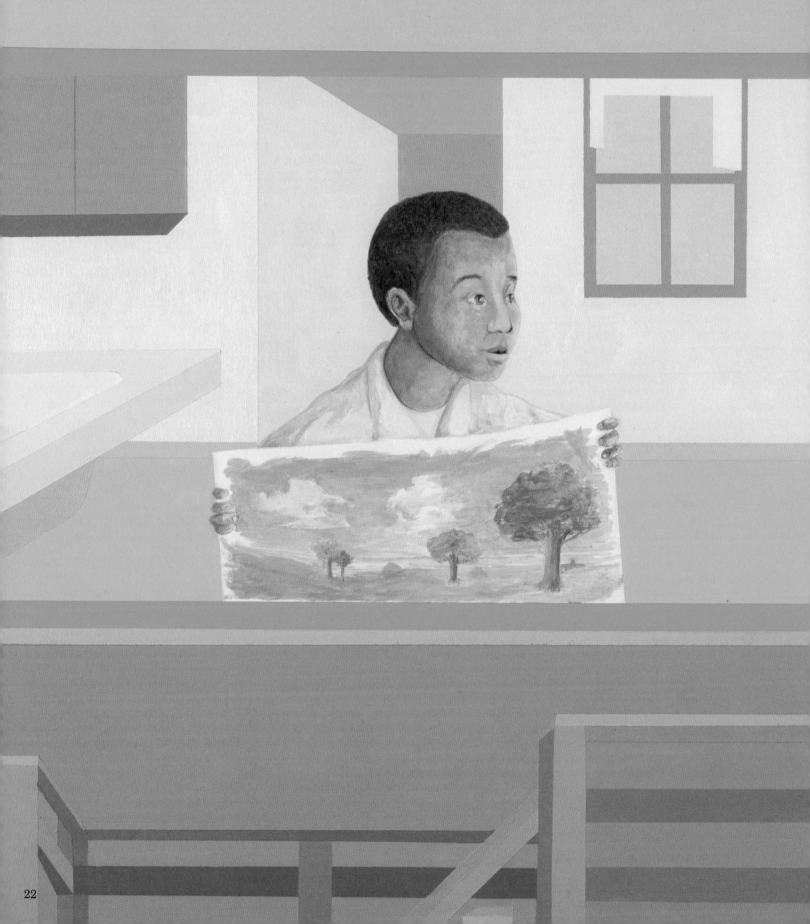

He thought his mother would be so surprised. She was surprised, all right, but she was not pleased!

Charles was an artist but he had a lot more work to do. He had to think about what he wanted his artwork to look like and what he wanted it to be about.

Charles loved the history stories that he read in the library. He also loved his own family's stories, which he learned from his Aunt Harriet, his Aunt Missouri, and his Great-Aunt Hasty. Every summer, his mother took him by train to visit them in Mississippi.

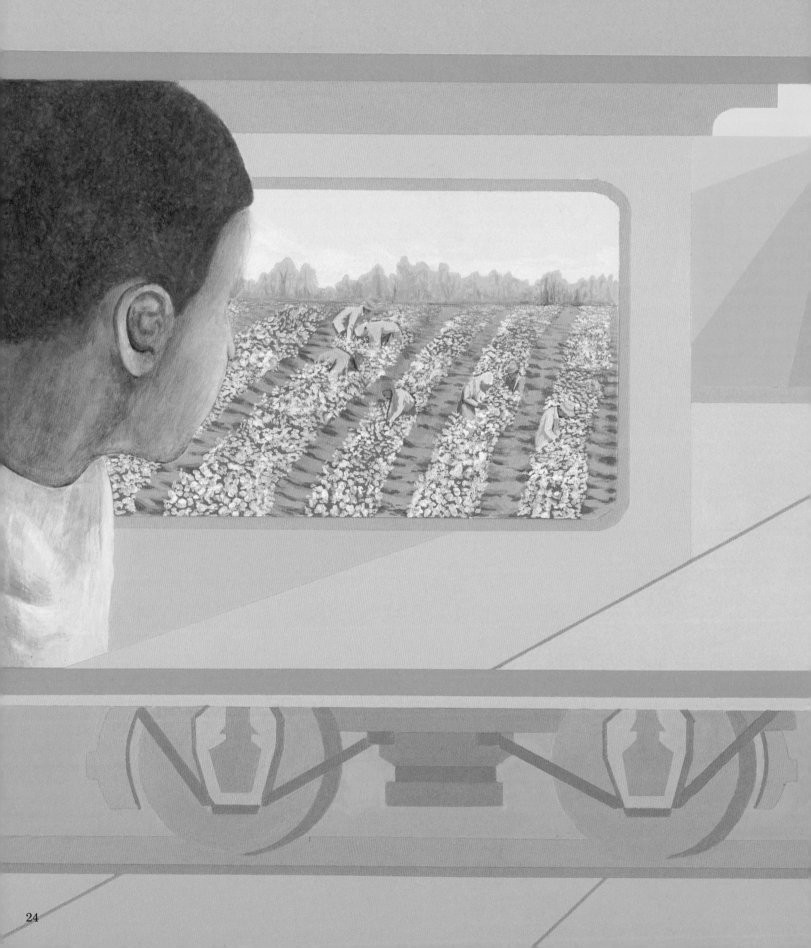

They told him about his family—their mothers and fathers, aunts and uncles—and about people who had been enslaved, like Great-Aunt Hasty. They told him about life in the South and life in the country, about working on a farm.

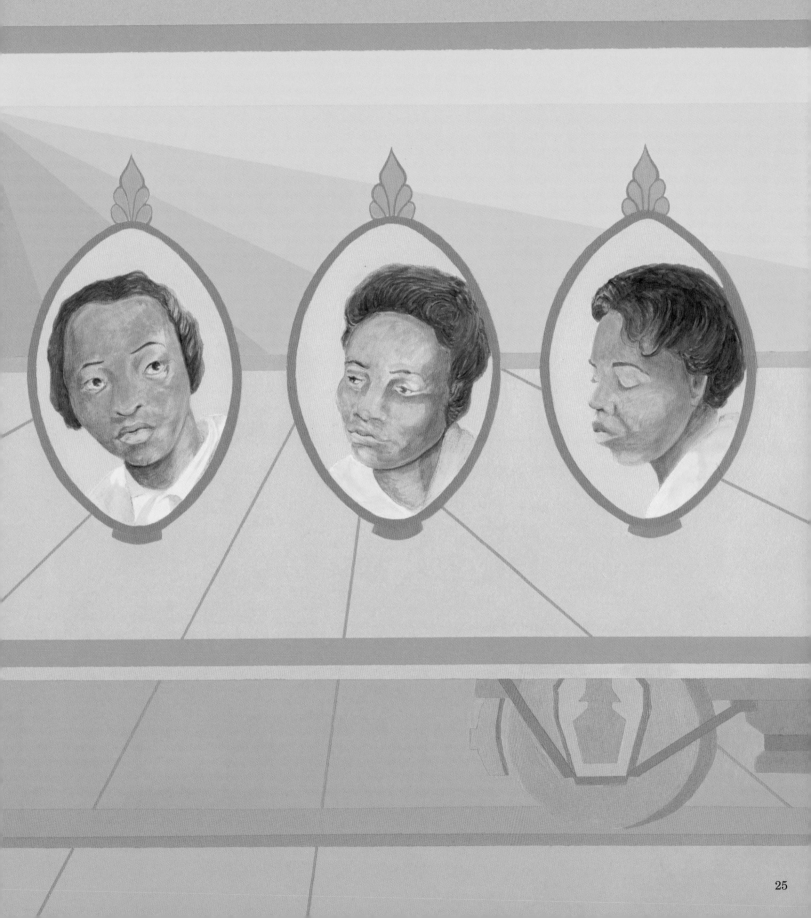

Charles wanted to tell these stories in his pictures. As he got older and took classes at the Art Institute, he learned more about painting and drawing. He discovered how to paint his stories in ways that showed how important they were to him.

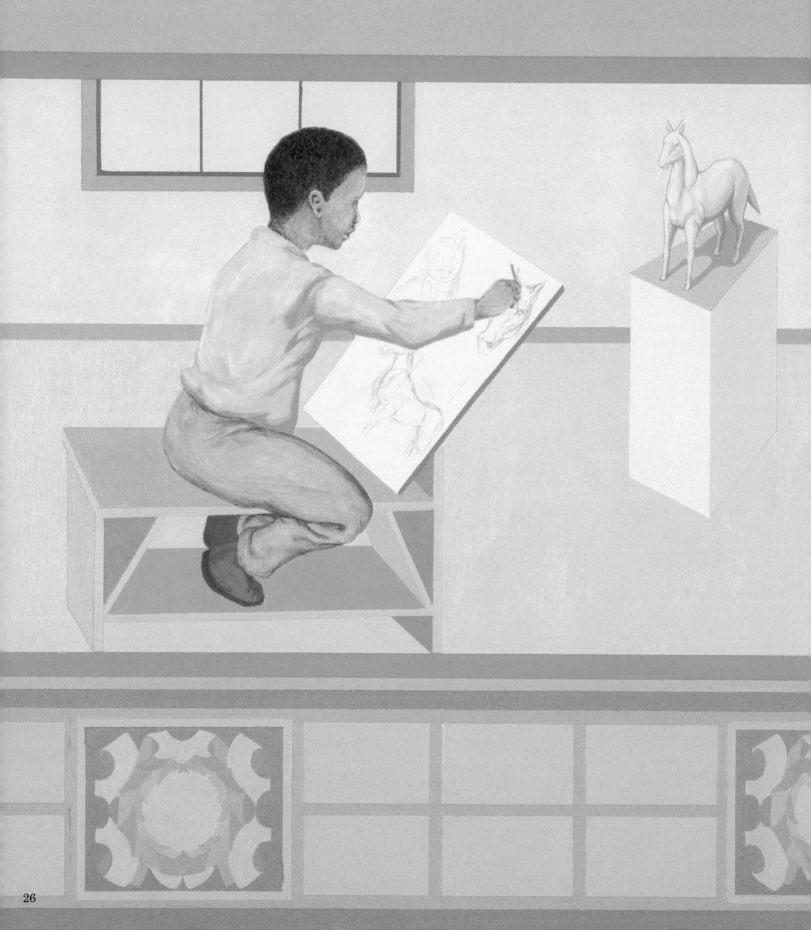

He never stopped learning about art, and he never stopped studying. He kept reading, and he kept looking at art, even when he grew up.

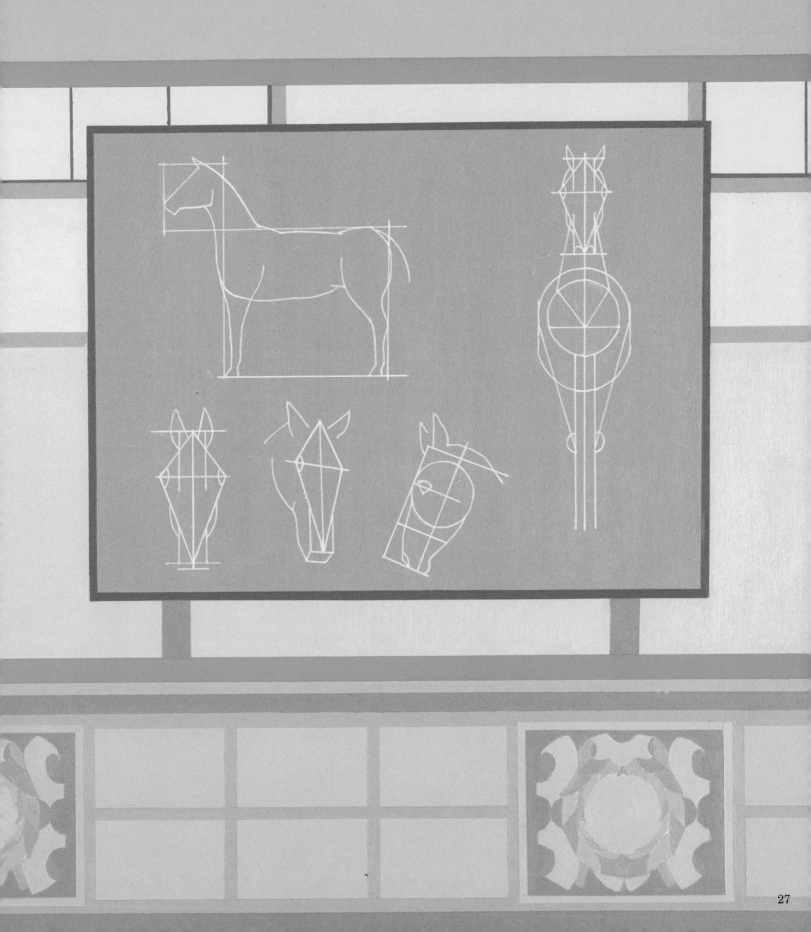

What did Grandpa paint?

Grandpa painted African Americans. He painted mothers, fathers, and children. He painted people who were enslaved, and the people who worked to free them. He painted writers, musicians, scientists, and leaders. He painted them marching and singing, thinking about freedom and working to make the world better.

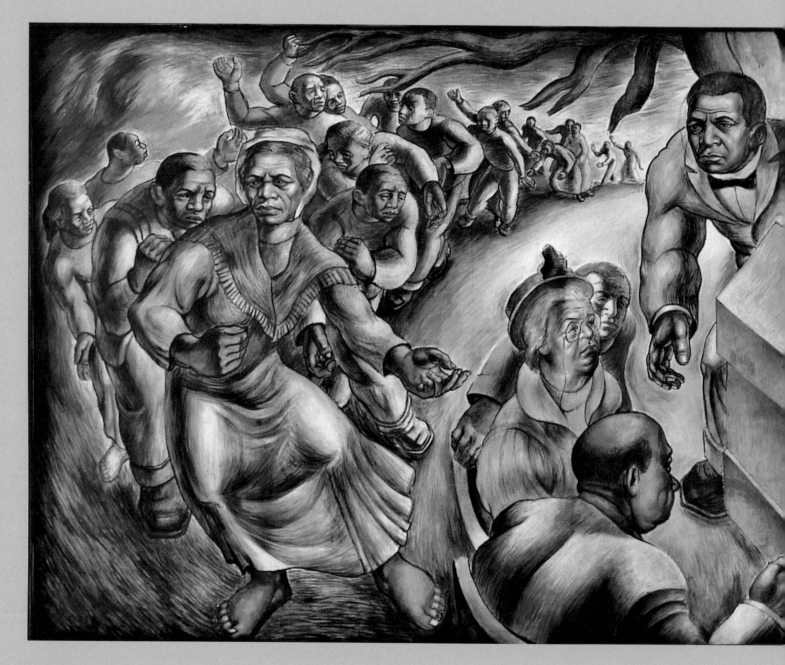

Charles White (American, 1918–1979)
Five Great American Negroes. 1939–40
Oil on canvas, 60 in. × 12 ft. 11 in. (152.4 × 393.7 cm).
Howard University Gallery of Art, Washington, D.C.

He painted important people such as Frederick Douglass, Harriet Tubman, Harry Belafonte, and Mahalia Jackson. He painted portraits of strangers and loved ones, scenes of struggle and triumph. He painted murals that became part of the buildings they were painted on and the cities that the buildings were in.

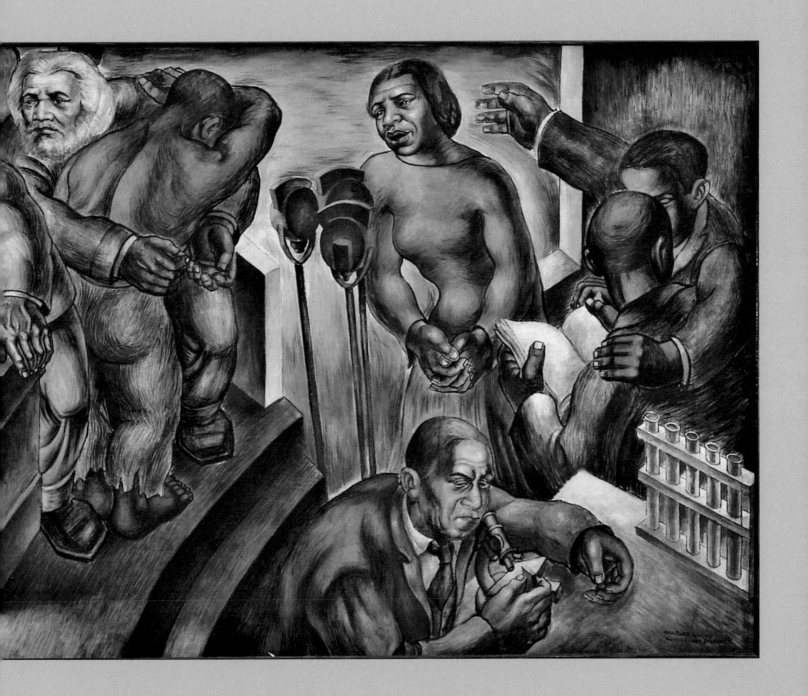

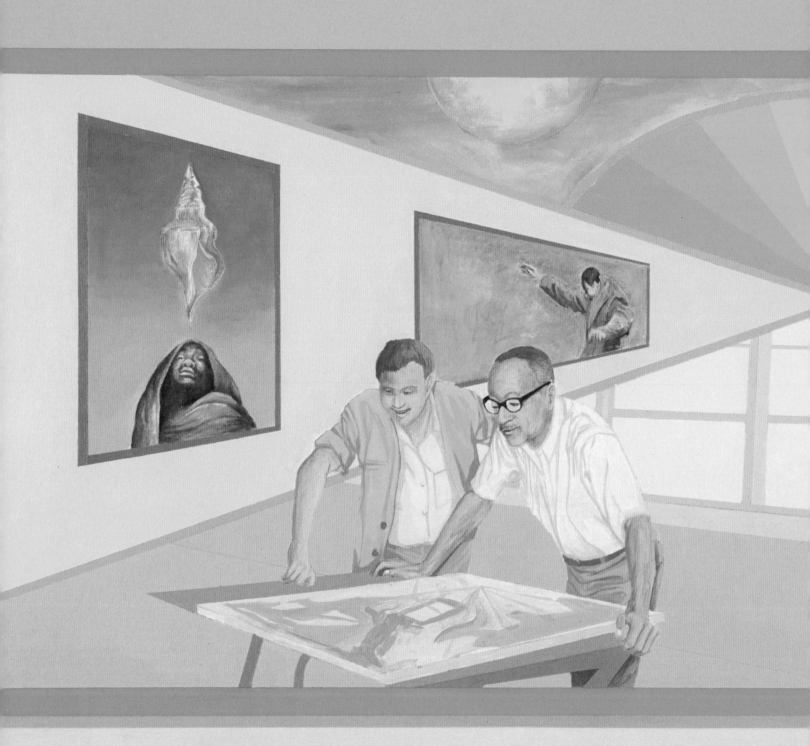

Charles became an artist and he also became a teacher. Some of his students are now famous artists, just like him. He taught them how to make art about things that were important to them. He taught them that their voices, ideas, and stories were valued. And they are.

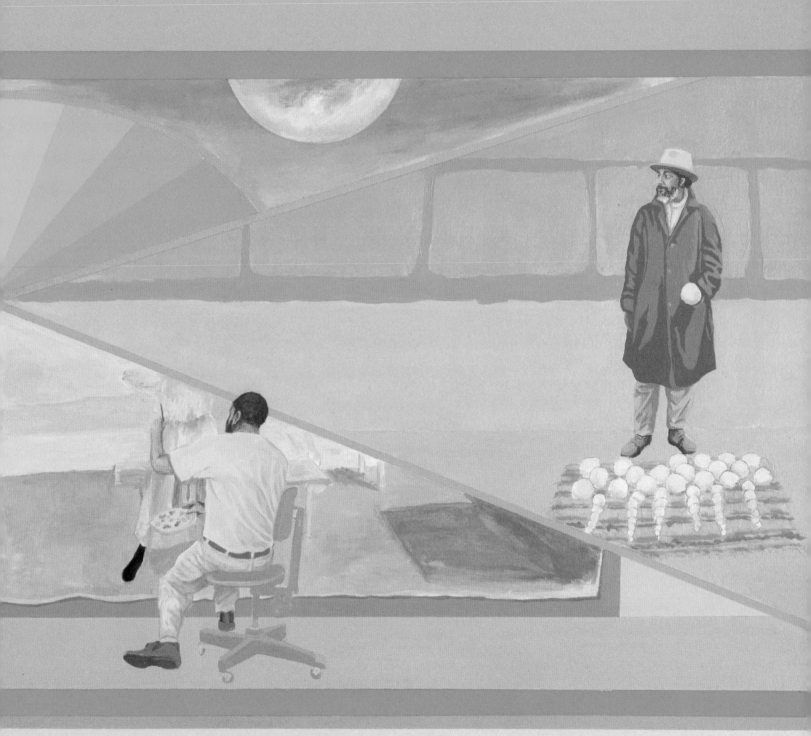

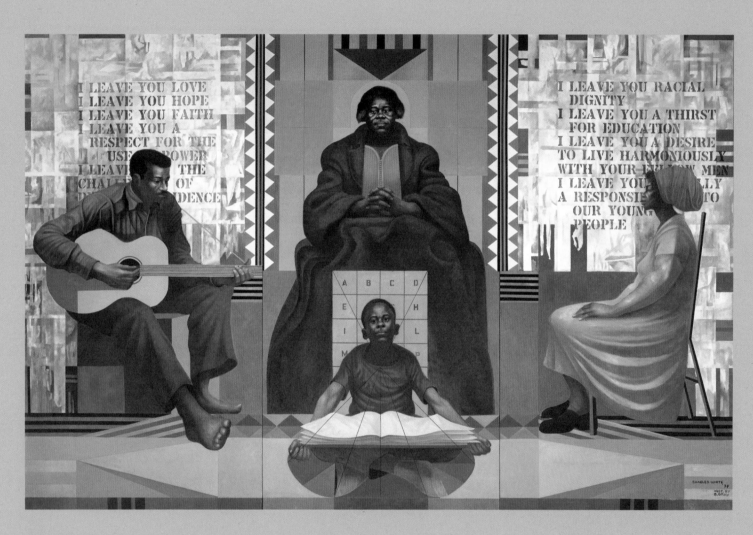

Mary McLeod Bethune. 1977
Oil on canvas, 10 × 14 ft. (304.8 × 426.7 cm)
Dr. Mary McLeod Bethune Regional Library,
Exposition Park Los Angeles Public Library

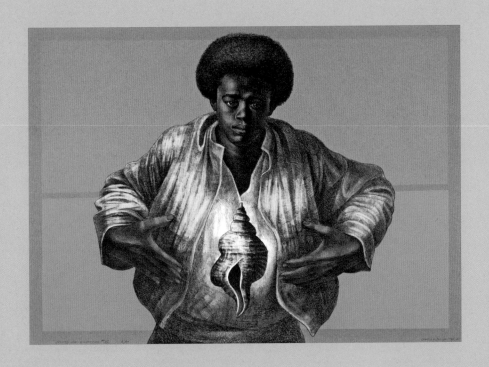

Sound of Silence. 1978
Color lithograph, 25⅛ × 35 5⁄16 in. (63.8 × 89.7 cm)
Printed by David Panosh
Published by Hand Graphics, Ltd.
The Art Institute of Chicago, Margaret Fisher Fund

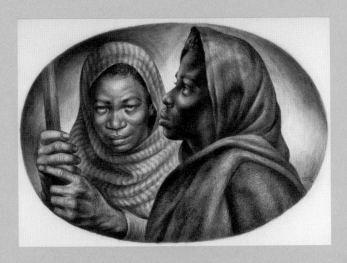

General Moses and Sojourner Truth. 1954
Wolff crayon and white chalk over traces of graphite pencil
with scratching out, blending, and charcoal-wash splatter,
27⅛ × 38 in. (70.8 × 96.5 cm)
Blanton Museum of Art, The University of Texas at Austin.
Gift of Susan G. and Edmund W. Gordon to the units of
Black Studies and the Blanton Museum of Art at the
University of Texas at Austin

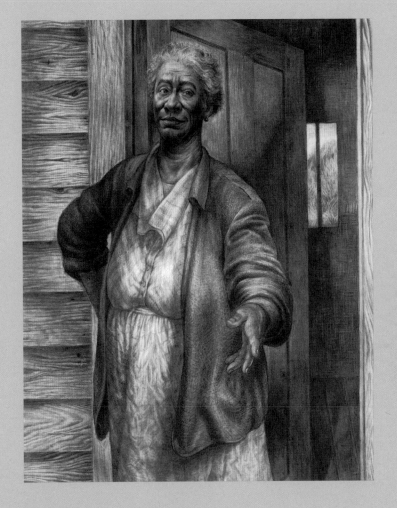

I've Been Buked and I've Been Scorned. 1956
Compressed and vine charcoal with carbon pencil and charcoal-wash
splatter over traces of graphite pencil, 44⅝ × 35⅜ in. (113.4 × 89.8 cm)
Blanton Museum of Art, The University of Texas at Austin. Gift of
Susan G. and Edmund W. Gordon to the units of Black Studies and
the Blanton Museum of Art at the University of Texas at Austin

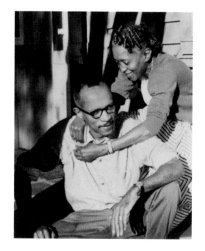

Charles White with his mother,
Ethelene Gary Marsh, 1958
The Charles White Archives

I look to the life of my people as the fountainhead of challenging scenes and monumental concepts.

—*Charles White*

Charles White was born in 1918, in Chicago, where in the 1930s he became a critical member of a budding community of African American artists. His career took him to New York, through the American South and Mexico, and ultimately to Los Angeles, where he lived and worked for more than twenty years. In all of these places, White contributed to the local art scenes and established ties with a range of creative people: writers, musicians, and performers as well as other visual artists. In addition to being a highly skilled draftsman, painter, and printmaker, he was a dedicated teacher, and he helped inspire and shape the careers of several generations of artists.

White made work that is figurative and representational, featuring images of African Americans drawn from history and tradition to reveal and celebrate their considerable, if often overlooked, accomplishments. His goal, he said, was "to make a very broad universal statement about the search for dignity, the search for a deeper understanding of the conflicts and contradictions of life. . . . What I'm trying to do is talk about the history of humanity." By the time of his death in 1979, White was widely admired for his "images of dignity" and his efforts to share his vision with the widest possible audience.

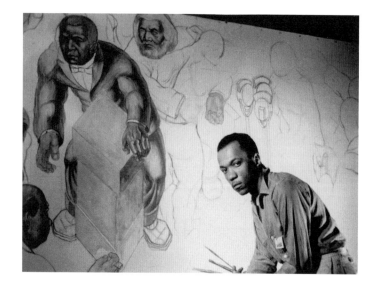

Charles White working on *Five Great American Negroes*, 1939
The Museum of Modern Art Archives

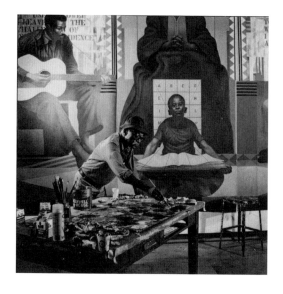

Charles White working on the mural
Mary McLeod Bethune, 1977
The Charles White Archives

This book is dedicated to my mother and father, Frances and Charles, to my wife, Virginia, and to my son, Gordon.

Produced by the Department of Publications
The Museum of Modern Art, New York

Christopher Hudson, Publisher
Don McMahon, Editorial Director
Marc Sapir, Production Director

Designed by Amanda Washburn
Production by Matthew Pimm
Printed and bound by Ofset Yapimevi, Istanbul

This book is typeset in New Century Schoolbook. The paper is 150 gsm Amber Graphic.

Children's Book Working Group: Cerise Fontaine, Samantha Friedman, Cari Frisch, Emily Hall, Hannah Kim, Elizabeth Margulies, and Amanda Washburn

With thanks to Esther Adler, Naomi Falk, Karen Grimson, Megan Kincaid, and Wendy Woon

C. Ian White wishes to thank the following people and organizations for their help and support: Ruben Delgadillo, Ha Phuong Ly, Crystal Thai, Gema M Martinez-Valadez, Alvaro Hernandez, Mike Rodgers, Anne Scott, Esther Adler, Marlene Matsui, Dr. Kellie Jones, Dr. Edmund and Dr. Susan Gordon, Hammons Foundation, The Charles White Archives, The Museum of Modern Art, and DJ-Ty Goodwin

Library of Congress Control Number: 2018944952
ISBN: 978-1-63345-065-3

Published by The Museum of Modern Art
11 West 53 Street
New York, New York 10019
www.moma.org

Distributed in the United States and Canada by Abrams Books for Young Readers, an imprint of ABRAMS, New York

Distributed outside the United States and Canada by Thames & Hudson Ltd., London

Printed in Turkey

Photograph credits
C. Ian White illustrations photographed by Natalja Kent, SOManifest.com

Photograph by Milli Aplegren: 33 (bottom left and right)
© The Art Institute of Chicago: 33 (top)
Courtesy Howard University Gallery of Art, Washington, D.C.: 28–29
Photograph by Natalja Kent: 32
© The Museum of Modern Art, New York; licensed by SCALA/Art Resource, NY; photograph by John Wronn: 34 (bottom left)
Courtesy The Charles White Archives: back flap, 34 (top, bottom right)

DATE DUE			

GLOVEMEN

TWENTY-SEVEN OF BASEBALL'S GREATEST

George Sullivan

Atheneum Books for Young Readers

Atheneum Books for Young Readers

An imprint of Simon & Schuster Children's Publishing Division

1230 Avenue of the Americas

New York, New York 10020

Book design by Ed Noriega

The text of this book is set in Century Old Style.

First Edition

Printed in the United States of America

10 9 8 7 6 5 4 3 2 1

Library of Congress Cataloging-in-Publication Data

Sullivan, George.

 Glovemen: twenty-seven of baseball's greatest / George Sullivan.

 — 1st ed.

 p. cm.

 Includes index.

 Summary: Profiles twenty-seven talented fielders in the history of

baseball, including Barry Bonds, Nap Lajoie, and Joe DiMaggio.

 ISBN 0-689-31991-6

 1. Baseball players—United States—Biography—Juvenile literature.

 2. Fielding (Baseball)—Juvenile literature.

 [1. Baseball players. 2. Fielding (Baseball)] I. Title.

 GV865.A1S894 1996

 796.357'092'2—dc20

 [B] 95-24749

Contents

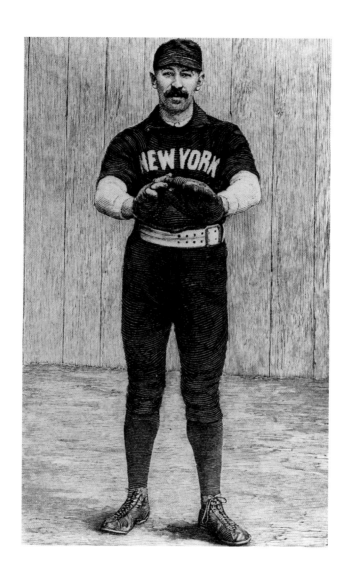

Like other players of the day, Buck Ewing, one of baseball's best catchers of the 1880s, wore gloves on both hands. *(New York Public Library)*

Introduction

Home runs and good pitching fill ballparks, put people in the seats; defense doesn't. But defense wins games as surely as timely home runs and 98-mile-an-hour fastballs.

Despite its critical importance, most fans usually take fielding skills for granted. They may admire an exceptionally skilled fielder; they respect him. But it's the sluggers who draw the loudest cheers.

Team owners have the same attitude. Except in the case of a catcher or a shortstop, teams usually choose players for their hitting or pitching ability. More than a few major-league outfields include at least one player of mediocre fielding skills who is in the lineup on a daily basis because he can hit.

The public usually thinks of defense in terms of plays that look spectacular—the shortstop who leaps high to spear a vicious drive or the outfielder who races in to make a diving catch of a sinking liner. Any leaping, tumbling, acrobatic catch gets lavish praise and certain TV coverage.

But the truth is that good defense depends on consistently making the routine play. Good defense relies on the infielder who plays nine innings and makes several assists and putouts, and not a single error. And he does it day after day after day. It's the outfielder who can go and get the ball and always throws to the right base.

Good fielding takes physical skill and a quick mind. You have to be able to react quickly, run fast, and handle the ball deftly. But fielding also requires the ability to anticipate, that is, to realize in advance which way the ball is going to go. You have to be able to get "a good jump on the ball."

Each batter has certain characteristics and the various fielders must adjust accordingly, moving to the right or left, in or out. The type of pitch being thrown and the game situation also have a bearing on where the fielder positions himself.

Getting positioned correctly is only part of it. The fielder has to be aware of all the tactical possibilities and be prepared to make the right play. Should an infielder go for the double play or try to get the sure out, the runner speeding for first? In the case of an outfielder, should he attempt to throw out a runner going from first to third or

Gloves of the early 1900s protected the hand but were not of great help in making fielding plays. *(New York Public Library)*

should he make certain the hitter doesn't reach second? On each play, there are countless such questions to be answered, and answered very quickly, between the time a ball leaves the bat and enters a fielder's glove.

This book profiles 27 of baseball's best fielders of the present and past. It describes the special skills of each and in so doing demonstrates the fine but less obvious art of baseball defense.

Picking baseball's 27 greatest defensive players of all time is no easy matter. The task would be eased a bit if one could select three players for each of the nine positions. The problem with that approach is that the fifth or sixth best fielding catcher or shortstop may be a better defensive player or have played, over time, a more important defensive role for his team than the second or third best fielding pitcher or left fielder. The

idea of this book is to profile the 27 best, regardless of position.

Statistics have been helpful in making the selections, but only moderately so. Take fielding averages, for instance, long a standard for rating defensive players. A fielding average is figured by adding a player's putouts (a play in which a fielder retires a batter or base runner), assists (a fielding and throwing play that enables a teammate to put out a runner), and errors to get his total chances. The number of putouts and assists is then divided by the total chances. (See sample computation on page 66.)

But fielding averages, by their nature, relate to one's position. That means, looked at in a different way, there are nine different sets of statistics (or seven sets if you make no distinction among left, center, and right fielders).

Because putouts and assists are not the same for each position, varying in type and frequency, fielding averages vary dramatically from one position to another. A fielding average of .965 is fine for a third baseman, but a first baseman with such an average would be considered ham-handed.

Seven different sets of statistics also means that no benchmark numbers are generated for fielders. There are no statistics that compare to a .300 batting average, 20 wins for a pitcher, or 100 RBIs for a slugger, numbers that are instant indicators of excellence.

Even the fielding averages among players at one position have to be questioned as a guide. Ozzie Smith, for example, who has been hailed as the best fielding shortstop of all time, was not a league leader in fielding averages among shortstops. Smith had tremendous range; but because he did, he got to a greater number of balls. So he made more errors, which were reflected in his fielding average.

Or take first baseman Steve Garvey's 19-year career with the Los Angeles Dodgers and San Diego Padres in the 1970s and 1980s. Garvey is the

only player ever to have had a "perfect" season at first base, compiling a 1.000 fielding average in 1984. And he achieved a .999 average in 1981. But Garvey had little range, a mediocre arm, and was known to often allow a runner to take an extra base rather than make the throw and risk an error.

The other categories used for judging players as fielders—assists, putouts, chances per game, and total chances—are important, but only when judged in relation to other statistics and their historical context. For example, the number of assists a player has is often used as an indication of his range. And why not? Any player who makes a higher than average number of throws to teammates, resulting in putouts, must be covering a good bit of ground.

But assists can hide other underlying factors. A second baseman with an exceptionally high total of assists, for example, may get some of those because the shortstop has great range. The shortstop makes the play, then uses the second baseman as the pivot man on double plays. The second baseman gets the assist.

Historical context is also always important. The game that came to be called baseball was originally played bare-handed. Of course, the ball stung when caught. During a game, infielders' fingers and hands became painfully swollen and bruised.

In this early era, misplays occurred much more frequently than they do today. Error totals were much higher and fielding averages much lower.

As players' skills improved and batters began to lash the ball with greater power, the need to protect the hands increased. Finally, one day in 1875, St. Louis first baseman Charles Waite took the field wearing a thin, flesh-colored, street-dress leather glove on his fielding hand. The fans, opposing players, and even his teammates hooted at poor Waite for his wimpy behavior. But some of the leading players of the day followed Waite's lead, and it wasn't long before gloves were being used at all positions. These early gloves resembled golf gloves of the present day. The fingers and thumb were snipped off just above the first joint and a small amount of padding was inserted to protect the palm. Catchers often wore two gloves.

During the 1880s, several changes in the rules altered the game significantly. Until then, the pitcher had always thrown the ball underhand, as in softball. But by the end of the 1880s, he was permitted to throw overhand. As a result, catchers began wearing thickly padded gloves on the catching hand. They continued to wear a thin leather glove on the throwing hand.

Not until 1891, however, did the catcher's mitt begin to resemble the mitts in use today. That year, the A. G. Spalding Company received a patent for a circular-shaped, pillowlike mitt.

Glove technology took another giant step forward in 1920 when Bill Doak, a spitballing pitcher for the St. Louis Cardinals, approached Rawlings Sporting Goods with the idea for a glove that included a multithong web between the thumb and first finger. This created a convenient pocket in which the ball could easily be trapped. The Doak model remained popular for 30 years.

In recent times, countless glove innovations have been introduced. These include the hinged heel and basket

Catchers' mitts once had a pillow-like appearance.
(New York Public Library)

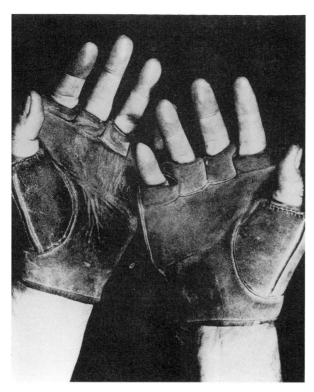

Early gloves had little padding, and fingers and thumb were left unprotected. (National Baseball Hall of Fame and Museum)

cial surfaces mean no pebbles ever interfere and bad bounces are rare.

The newer "cookie cutter" ballparks have also removed some of the fielders' challenges. They're perfectly proportioned. There are no lopsided distances, no special characteristics, such as the "Green Monster" at Boston's Fenway Park or the menacing left-field scoreboard at Pittsburgh's old Forbes Field.

In recent decades, thanks to computers, the analysis of baseball statistics has grown by leaps and bounds. The increased emphasis on the statistical analysis of baseball records has produced new measures for evaluating player performance. In the case of fielders, we now have the fielding run, a statistic that reports how many runs a particular fielder has saved (or cost) his team as compared to a player of average skills at the same position. For example, Keith Hernandez compiled 150 fielding runs during his career, making him the all-time leader among first basemen in this category. The aforementioned Steve Garvey, over his career, cost his teams 115 runs. Fielding runs are considered quite meaningful in judging player performance. The Gold Glove Award, properly called the Rawlings Gold Glove Award, is another guide used in selecting the players profiled in this book. Major-league managers and coaches make the Gold Glove selections at the end of each baseball season. *The Baseball Encyclopedia* calls the Gold Glove "probably still the best tool we have available to rate fielders." A complete list of Gold Glove selections begins on page 69.

Despite the availability of Gold Glove choices and all the other statistics, wisely considered, picking the 27 greatest fielders is something less than exact science. Some players who perhaps should have been included have not been. Nellie Fox and Bob Gibson are two examples.

But the basic idea of the book is not to state unarguable fact so much as to salute great fielders and their special skills.

web, the six-finger Trap-Eze, the snug-fitting Fastback, and the unique Spin Stopper that cuts the ball's spin on impact with the pocket. The result is that the modern-day glove bears only the slightest resemblance to gloves of earlier days.

The baseball itself also has an effect on fielding and fielding statistics. In baseball's so-called dead-ball era, before 1920, outfielders positioned themselves much shallower than they do now. They had no fear of the ball going over their heads. Outfield assists, a standard for judging excellence in the outfield, were a great deal more common in those days than they are today because those fielders were closer to the base runners.

Two other reasons it's difficult to compare fielders of the past with those of the present day are the changes in types of playing surfaces and stadium construction. Artificial surfaces have made baseball a far different game. For fielders, artifi-

Barry Bonds

LEFT FIELD
Born: July 24, 1964; Riverside, California
Height: 6'1" Weight: 185
Throws left-handed, bats left-handed

The best and richest ballplayer of the 1990s is a left fielder. Except for the first of the seven seasons he spent with the Pittsburgh Pirates, when he played center field, Barry Bonds's entire career has been in left. "I'm a natural at the position," he says.

Barry Bonds, who took the free-agent route from Pittsburgh to San Francisco in 1992, is acclaimed for his all-around play, for his power and speed, as well as for his fielding. But fielding came first. From his Little League days in San Carlos, California, Bonds was schooled in playing the outfield. He had some exceptionally qualified teachers. His father, Bobby Bonds, baseball's second 30-30 player (30 home runs, 30 stolen bases) played right field for the Giants. His godfather, Willie Mays, played alongside his father.

The two taught Barry that there's a great deal more to left field than catching everything that can be caught and cutting off everything else. Barry learned how to study hitters and the importance of keeping alert, ready for each moment. He learned the ins and outs of outfield communications—positioning, backing up, and directing throws.

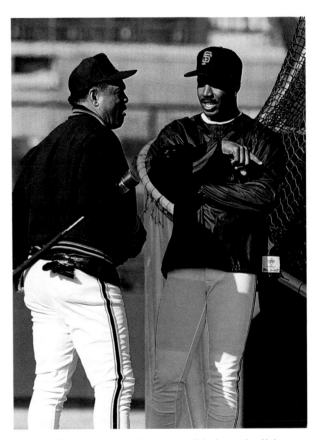

Above: **Bonds (right) chats with baseball legend Willie Mays, a San Francisco coach, at the team's training facility in Scottsdale, Arizona.** *(Wide World)*

The Giants had an opportunity to sign Barry after he graduated from Serra High, an all-boys Catholic school, where he proved to be a gifted athlete. But when the club refused to offer him more than $70,000, Barry decided to go to Arizona State.

After he joined the Pittsburgh organization in 1985, the club assigned him to Prince William in the Carolina League. The following year he moved up to Hawaii in the Triple-A Pacific Coast League. One day during a batting practice before a game in Phoenix, Syd Thrift, general manager of the Pirates, saw Bonds pull five or six balls over the right-field fence. "Any good hitter can do that," Thrift told Bonds. "I'd like to see you hit a few over the left-field fence." Bonds hit five in a row. Thrift took Bonds back to Pittsburgh that night.

During his rookie year with Pittsburgh, Bonds played center field. But when Andy Van Slyke joined the team in 1987, manager Jim Leyland put Van Slyke in center and switched Bonds to left. Leyland made the change partly because Bonds wanted to play left but also because his talents fitted the position so well. "In left," said Leyland, "you have to get to balls faster and make plays quicker than anywhere else." He felt Bonds had great instincts about base runners, what the situation was, and when to charge and when not to.

After seven years with the Pirates, Barry filed for free agency and the Giants outbid the Atlanta Braves to land him. The cost: $43.75 million for six years. It was the most lucrative contract in baseball history.

Nobody said that Barry was overpaid. At Pittsburgh, he had won three Gold Gloves and two Most Valuable Player Awards. In his first season with the Giants, he wrapped up a fourth Gold Glove and a third MVP trophy, his third in four seasons. (In the MVP voting in 1991, Bonds lost to Terry Pendleton, then the Atlanta third baseman, by a very slim margin, 274 to 259 points. Had Bonds won that year, his MVP Award in 1993

would have been an unprecedented fourth award, not to mention four in a row, and he was only 29.)

Bonds won a fifth Gold Glove in 1994. He and his father, a Gold Glove winner in 1971, 1973, and 1974, hold the distinction of being baseball's first father-son Gold Glove combination.

In the four seasons from 1990 to 1993, Barry averaged 114 RBIs, 34 home runs, and 40 stolen bases. After he hit two homers in a game against the Mets in 1993, Jeff Torborg, then the New York manager, told *Sports Illustrated*, "Bonds belongs in a higher league."

Bonds himself sometimes appears to agree with this opinion. He can be moody, even rude. When a game is over, he doesn't believe in hanging around and signing autographs. He leaves. "If fans pay $10 to see Batman," he said, "they don't expect to get Jack Nicholson's autograph."

It doesn't seem to matter to Barry what people think. "All he's ever wanted," one of his Pirate

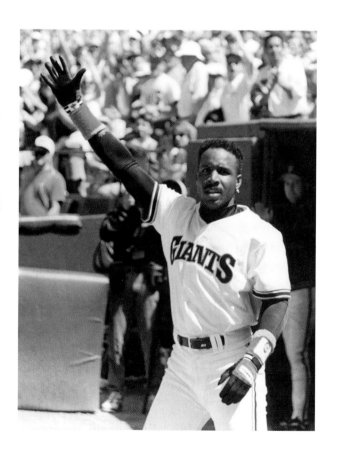

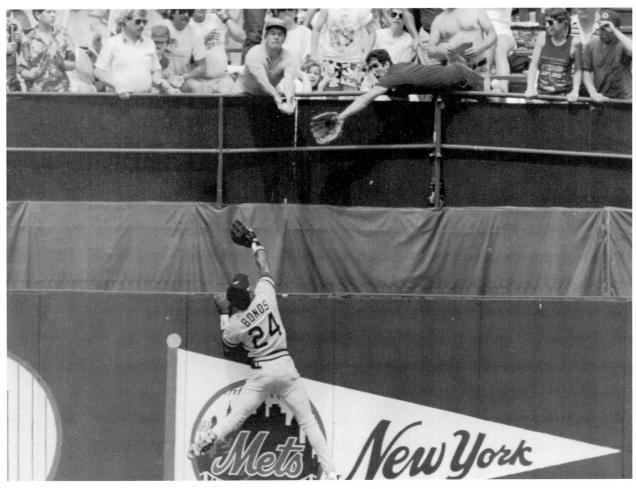

teammates once said, "is to be judged by what he's done on the field."

Despite all of his individual achievements, Bonds still feels unfulfilled because he has never played in the World Series. He's come close several times. In his years with the Pirates, the team won the division championship three times but failed to advance. (In those three series, Bonds had a combined batting average of .191.) In his first season with the Giants, the team won 103 games but didn't win the division title because the Atlanta Braves won 104. The Giants were second again in strike-disrupted 1994.

"I still have unfinished business," said Bonds in an interview in the *New York Times*. "You can win all the MVP Awards, but I need to win. I don't want to say I went home with three MVPs, but I never won. I'd like to go home a winner and toss away one of those MVPs."

Bonds leaps high—but not high enough—in an effort to nab a long drive off the bat of Kevin Elster of the Mets early in the 1989 season. *(Wide World)*

Left: A teammate once said of Bonds, "All he's ever wanted is to be judged by what he's done on the field." *(Wide World)*

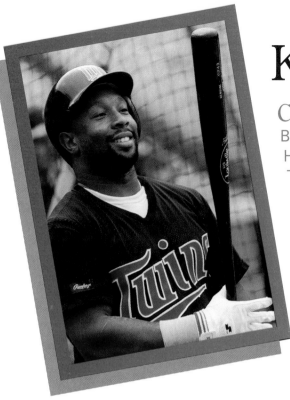

Kirby Puckett

CENTER FIELD
Born: March 14, 1961; Chicago, Illinois
Height: 5'8" Weight: 215 pounds
Throws right-handed, bats right-handed

Kirby Puckett of the Minnesota Twins doesn't look like a center fielder. At five-foot-eight, 215 pounds, he's almost as round as a bowling ball. He seems out of place at his position.

Puckett—or "Puck," as he is called—grins when he talks about his body. "People always come up to me and say, 'Man, I thought you were bigger.' I shake my head and say, 'Nope, this is it, this is the way I look.' You don't get to pick your body. God just hands them out as he sees fit."

Puckett's unusual build hasn't prevented him from becoming baseball's best center fielder since Willie Mays. He climbs walls to make game-saving catches, has been voted by American League managers (along with Boston's Dwight Evans, who retired in 1981) as having one of the two best outfield arms in the league, and has won six Gold Glove Awards (through 1994).

Puckett hits the ball shockingly hard. He has led the league in hits four times and he won the league batting title in 1989 with a .339 average. He has World Series rings from 1987 and 1991.

The youngest of nine children, Puck was brought up in the Robert Taylor Homes, a project on the South Side of Chicago. At night, his parents would hear a constant clatter from his bedroom, where he and his brothers were playing indoor baseball with rolled-up socks and aluminum foil bats.

After school and on weekends, he and his friends laid out makeshift diamonds on project streets. The strike zone would be scratched onto the side of a building with chalk or a stone. "Even when I was eight years old, I felt like something special," Puckett once told sportswriter Mike Lupica, "because when I was eight, I was already playing with kids who were older."

Puckett did not play organized baseball until high school, where he starred as a third baseman. At Bradley University, a coach moved him to center field because he ran so fast. The Minnesota Twins landed Puck in the third round of the 1982 draft. Two years in the minors followed.

Once Puckett joined the Twins, his numbers kept getting bigger. In 1986, he hit .328; in 1987, .332; and in 1988, .356, the highest of any right-handed batter since Joe DiMaggio hit .357 in

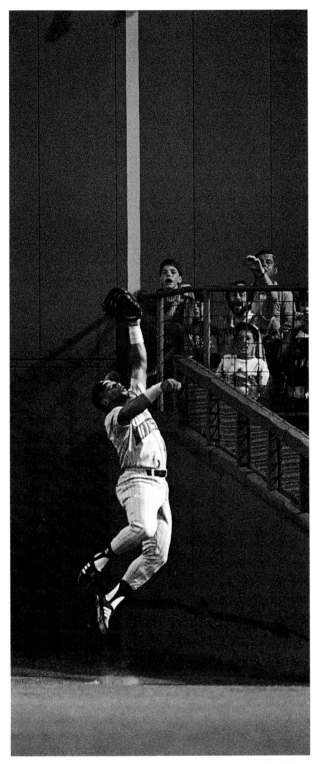

1940. And he also hit with power, averaging 20 homers a year.

While Puckett enjoys hitting the long ball, it's his exploits in center field that make his face light up. In an interview with *Sports Illustrated*, he said, "You know what I really like? Defense. I love it when a guy thinks he's hit a home run and I jump over the fence at the Dome and take it away. What a thrill!"

Puckett plays center field very deep. By playing back, he takes away the big hits. "My theory is that I want to take away balls over the wall," he says, "so I give up the shallow hit to do it." In one season, he plucked nine balls out of the air before they landed on the other side of the fence.

Puckett is able to play deep because he moves in on the ball fast and has an exceptionally strong arm. He throws low, flat, and very hard.

Center field is, arguably, the most demanding position in baseball. The center fielder has to be almost everywhere and catch almost everything. He has to be able to go back, come in, and move to either side. He has to have *range*. He has to be able to make all kinds of catches—over his head, over his shoulders, and off of outfield walls. Miss the ball in center field and it can mean an inside-the-park home run.

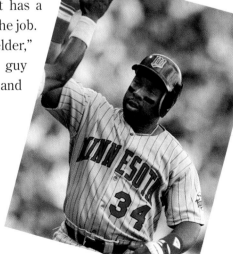

Kirby Puckett has a simpler view of the job. "The center fielder," he says, "is the guy who just goes and gets the ball."

Above: Puckett goes high in the air at Boston's Fenway Park in an attempt to snare Mike Greenwell's long drive. *(Wide World)*

Right: Puckett hits with power, averaging about 20 home runs a season. *(Wide World)*

Ozzie Smith

SHORTSTOP

Born: December 26, 1954; Mobile, Alabama
Height: 5'11" Weight: 150
Throws right-handed, bats right-handed and
left-handed

To many baseball observers, Ozzie Smith was the best fielding shortstop of all time. He is, after all, one of baseball's career leaders in Gold Gloves, with 13. Only two players have won more (pitcher Jim Kaat and third baseman Brooks Robinson). But to a growing number of experts, Smith has come to be regarded as the greatest defensive player, regardless of position, in baseball history.

"The Wizard of Oz" was his nickname. One of his long-remembered bits of magic occurred during a game between the Atlanta Braves and San Diego Padres in San Diego in 1978. (Smith broke in with the Padres that year.) Jeff Burroughs slammed the ball up the middle. Smith got his usual good jump on the ball, a one-bouncer headed into center field. He dove head-first to make the stop, his glove stretched out in front of him. But the ball struck a pebble and caromed in the other direction, to Smith's right. No problem. While still in midair, with his gloved hand extended for a ball that was never going to arrive, Smith reached back with his bare hand

Smith flips the ball to first base after making a diving stop. *(Wide World)*

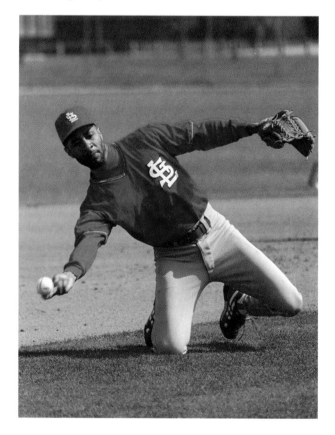

and snagged the ball. Then he scrambled to his feet and threw Burroughs out.

"Good defense," Smith once said, "means taking the momentum away from the team at bat and giving it to your team." Smith, who was traded to the St. Louis Cardinals in 1982, did that—and much more. The *Elias Baseball Analyst* calculates that Smith and his dazzling fielding saved the Cards 27 runs per season beyond what an average shortstop would have done. That figure translates into about three wins a year for the team. Smith also contributed as an above-average hitter and high-average base-stealer.

Osborne Earl Smith, born in Mobile, Alabama, attended Locke High School in Los Angeles. As a boy, he used to lie in his room alone, on his back, on the floor, and toss balls up at the ceiling. Just as the ball reached its height, he'd close his eyes and put out his hands and see whether he could catch it.

San Diego picked him in the fourth round of the 1977 free agent draft. After winning two Gold Gloves with the Padres and setting a record for assists in 1980, Smith was dealt to the Cardinals in 1982. The same year, the Cards won their first World Series in fifteen years. Smith led the league's shortstops in fielding percentage for a record seventh time. The Cards also won the pennant in 1985 and 1987, but lost both times in a seven-game World Series.

In 1991, Smith set a record for National League shortstops by committing only eight errors in 150 games. The same year, he won his eleventh Gold Glove. Smith won Gold Glove honors again in 1992 and 1993, bringing his total to 13. Only Brooks Robinson (with 16) and Jim Kaat (with 16) have more Gold Gloves than Smith. But Smith won his as a shortstop, and the shortstop is generally conceded to be the most important player on the field after the pitcher and catcher.

"I think I've gotten better as I've grown older," Smith said as his career entered the decade of

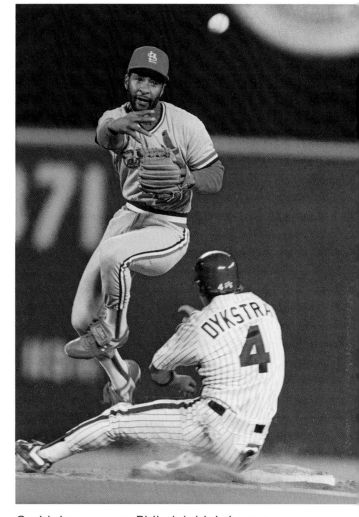

Smith jumps over Philadelphia's Lenny Dykstra in an attempt to complete a double play. *(Wide World)*

the 1990s. Baseball fans seemed to agree. They made the 39-year-old Smith the starting All-Star shortstop in 1994, casting more than 4 million votes for him. It was his thirteenth All-Star appearance and his eleventh as a starter. And the votes represented the biggest total given a National Leaguer that year. Smith responded in typical fashion, with a run-saving diving stop of a grounder that helped make the difference in the National League's 8-7 victory.

Don Mattingly

FIRST BASE

Born: April 20, 1961; Evansville, Indiana
Height: 6' Weight: 185
Throws left-handed, bats left-handed

Throughout most of the 1980s and well into the 1990s, Don Mattingly's day-in, day-out excellence at first base earned him a ranking with George Sisler, Mickey Vernon, Keith Hernandez, and the other all-time greats at the position. His stylish but aggressive defensive play was one of the important reasons for the Yankees' return to excellence, challenging for the pennant in 1993 and finishing first in their division during the strike-shortened 1994 season.

To Mattingly, playing first base always involved much more than the obvious tasks of catching thrown balls, keeping the runner on, and fielding grounders and bunts. He also excelled at the mental side of the game. "A good defensive first baseman is in the right place at the right time," he said. "He plays guys right, he knows when to play the lines and when not to, when to keep the runner close and when not to." Mattingly was a master of looping fly balls over his head, and he made the double play just about as well as anyone.

In his first decade or so with the Yankees, Mattingly came as close to being perfect as any infielder ever. By making only two errors in 989

chances during 1994, he led all first basemen with a .998 fielding percentage. Although that falls short of Steve Garvey's one-season 1.000, his remarkable performance enabled him to raise his career fielding percentage to .99599, the best of any position player in major-league history. (Steve Garvey is ranked second at .99594.)

Mattingly, who won the American League batting championship in 1984 with a .343 average, brought the same intensity to his hitting as he did to his fielding. "Each time I go up, I want to get a good pitch to hit and hit it hard," he told Murray Chass of the *New York Times*. "A lot of guys give away at bats. They make a mental mistake here, a mental mistake there." Mattingly didn't; he always tried to be ready.

Born in Evansville, Indiana, Mattingly was the youngest of five children, a girl and four boys. When Don was 9, he won the most valuable player award in Little League play for ages 9 through 12. He went to Reitz High in Evansville, where he played quarterback on the football team and guard on the basketball team, and pitched and played

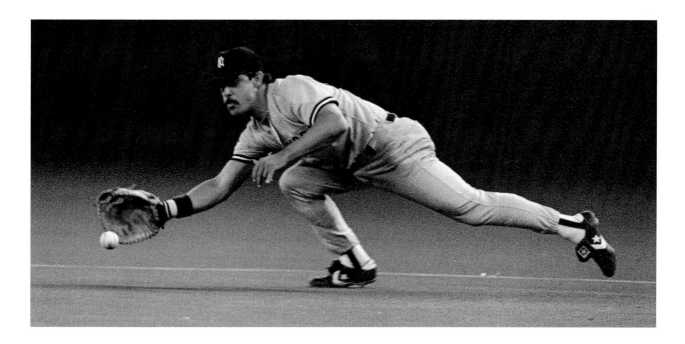

first base in baseball. Picked by the Yankees in the June 1979 free-agent draft, he went on to hit over .300 at every minor-league level.

In 1983, his rookie season with the Yankees, he played fewer games at first base than in the outfield. But in 1984, he was at first base full-time. He displayed remarkable quickness moving to the right to stop grounders in the hole. His .992 fielding average that year was the best among the league's first basemen.

One of the disappointments of Mattingly's career is that he has never played in a World Series. In 1995, the Yankees entered postseason play as a wild card team, but lost to the Seattle Mariners in the first round of playoff games.

Mattingly revealed earlier in the year that he is considering retirement. He said he has grown weary of working so hard off the field to simply be average on it. No one, it must be said, ever accused Don Mattingly of being average.

In 1994, Mattingly was close to perfect in the field. With only 2 errors in 989 chances, he led all first basemen with a .998 fielding percentage. *(Wide World)*

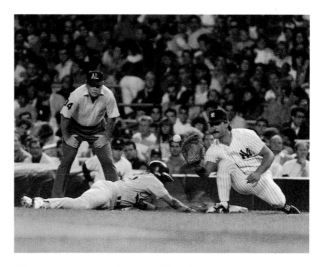

Mattingly stretches to his right to snag a ground ball off the bat of Andy Van Slyke during 1988 All-Star Game. *(Wide World)*

Jim Abbott

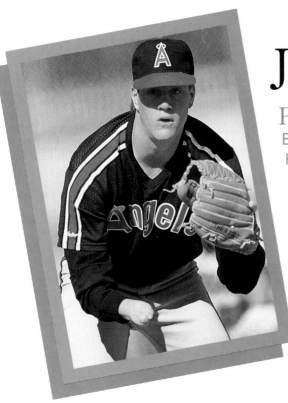

PITCHER

Born: September 19, 1967; Flint, Michigan
Height: 6'3" Weight: 200
Throws left-handed, bats left-handed

To do what Jim Abbott has done, to become one of baseball's finer pitchers, solid and aggressive in fielding the position, and do it with one hand, is extraordinary. Only a "special person," a term sometimes used to describe Abbott, could accomplish it.

Abbott, who joined the New York Yankees in 1992 after four seasons with the California Angels, was born without a right hand. There is a stub and small fingerlike protrusion where the right hand would be. He is the first and only one-handed pitcher in baseball history. Abbott dislikes the word "handicapped" and feels it doesn't apply to him. " 'Handicap' means limitation," he says, "and I've never felt limited in what I do." Abbott thinks of himself only as a ballplayer.

Abbott's recent history is evidence of that. Delivering burning fastballs, Abbott went from Flint (Michigan) High School to the University of Michigan, where he posted a 26-8 career record. His next stop was the 1988 Olympic Games in Seoul, South Korea. There he pitched the United States to a gold medal. The same year, Abbott won the James E. Sullivan Memorial Trophy as the nation's best amateur athlete.

Scouts agreed that Abbott had a major-league future. They timed his fastball at 94 miles per hour. But it takes only one hand to throw a fastball. What about fielding the ball?

Actually, fielding was never much of a problem for Abbott. He follows a precise routine that he perfected as a child by tossing a ball against a wall. The more skilled he got, the closer he moved to the wall, and the harder he tossed the ball.

As Abbott gets set to pitch, he rests his glove on the nub of his right arm, while his left arm moves over his head and he goes into his leg kick. After the ball is released and the left arm follows through, he quickly slides his left hand into the glove and comes around into a squared position ready to field the ball.

Suppose he catches a batted or thrown ball. He then slides his glove under his right armpit, seizes the ball with his left hand, and makes the play. It all happens in the blink of an eye. In fact, someone watching must view the process several times before understanding exactly what takes place.

At every stage of his career, teams have tried to attack Abbott's fielding. During his freshman season in high school, an opposing team began a game against him with eight consecutive bunts. The leadoff batter made it to first base safely but Abbott threw out the next seven. When asked how he reacts to a screaming line drive up the middle, he answers, "I do what everyone else does. I duck."

The California Angels made Abbott their first-round choice in the amateur draft. He never spent a day in the minor leagues. In 1989, as a rookie, he had a few rocky starts, but in mid-May that season he threw nine innings of shutout ball in a head-to-head duel with Roger Clemens of the Boston Red Sox. That game did more than any other to prove Abbott was a legitimate major leaguer, not a curiosity.

In the years that followed, Abbott has scored other notable successes. In 1992, he had a 2.77 earned run average, fifth best in the league (although his won-lost record was 7-15). The Angels traded him to the Yankees in the midst of a contract dispute. In 1993, his first year with the New York team, Abbott tossed a no-hitter against the Cleveland Indians, winning 4-0.

The pitching-rich Yankees released Abbott in 1994. He signed with the Chicago White Sox early in 1995, then was traded back to the Angels in mid-season.

His no-hitter was only one in a long list of accomplishments for Abbott. But he takes his greatest pride in the fact that he's appreciated for his sinking fastball, slippery slider—and excellence as a fielder.

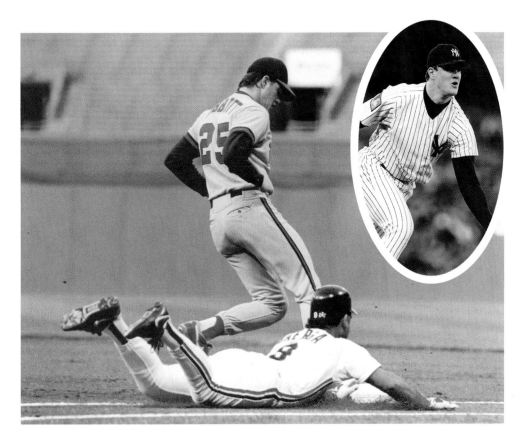

Far left: Abbott boasts a sinking fastball and tricky slider.
(Wide World)

Inset: Line drives, grounders and bunts were never a big problem for Abbott, who perfected his fielding skills during his boyhood years.
(Wide World)

Left: Abbott records a putout at first base, with Cleveland's Carlos Baerga the victim.
(Wide World)

Keith Hernandez

FIRST BASE

Born: October 20, 1953; San Francisco, California
Height: 6' Weight: 180
Threw left-handed, batted left-handed

For his ability to dig low throws out of the dirt, charge bunts and slow rollers, and range far and wide, Keith Hernandez was unrivaled at first base. And his knowledge of where to play each batter made him even more effective. Year in, year out, he captured the National League's Gold Glove Award, 11 in all, more than any other first baseman.

It was often said that Hernandez's moves at first base were pure textbook. The same could be said of his batting stroke, which made him one of the game's most consistent hitters. In 1979, with a .344 average, he became the first National Leaguer to win the batting crown *and* a Gold Glove in the same year. He also shared

Hernandez has 11 Gold Gloves, more than any other first baseman. Here he dives in vain for a line drive. *(Wide World)*

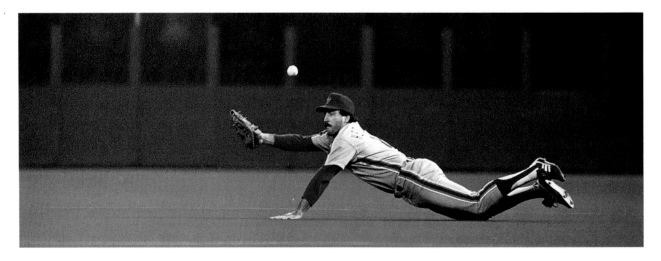

Big Red Machine, the name applied to the awesome Cincinnati Reds of the 1970s. On a team with Johnny Bench and Pete Rose, "Little Joe" (he stood five-foot-seven and weighed 150) won MVP honors twice, in 1975 and 1976, and captured Gold Glove honors for five straight years beginning in 1973.

The versatile Morgan had good speed, which, when combined with some daring baserunning, enabled him to average 60 stolen bases a season from 1972 through 1977. He scored more than 100 runs each of those years, averaged 21 homers, and maintained a .321 batting average. At one time or another, Morgan led the league in bases on balls (three times), slugging average, and sacrifice flies.

At second base, Morgan had good range and sure hands to go with his courage. In 1977, he set a record for second basemen, making only five errors. He once went 91 consecutive games without an error, another record.

When Morgan was four years old, his family moved from Texas to Oakland, California. He graduated from the same Oakland high school as Frank Robinson, a two-time MVP Award winner. Jackie Robinson was another of Morgan's early heroes. Later Morgan came to admire Nelson Fox, a defensive standout for the Chicago White Sox. Throughout his career, Morgan sought to follow in Fox's hustling footsteps.

Bill Mazeroski was another of Morgan's role models among second basemen. Mazeroski, who was known for his remarkable pivot on double plays, never made any great effort to get out of the way of the sliding runner either. Making the play was the thing. That was Morgan's credo, too.

Morgan was dealt to Houston in 1980. After a season with the Astros, he went on to two fine years with the San Francisco Giants. In 1983, Morgan was reunited with Pete Rose and Tony Perez, another Cincinnati teammate, in Philadelphia, where the trio helped the Phillies win a pennant. Morgan played with the Oakland A's in his final season. In his 22-year career, Morgan and his varied skills helped win six division titles, four pennants, and two world championships.

After his retirement, Morgan went on to a career as a baseball broadcaster for ESPN. He was selected to the Hall of Fame in 1990, his first year of eligibility.

Morgan rifles the ball to first base to complete a double play during 1983 World Series. Phillies lost to Orioles in 5 games. *(Wide World)*

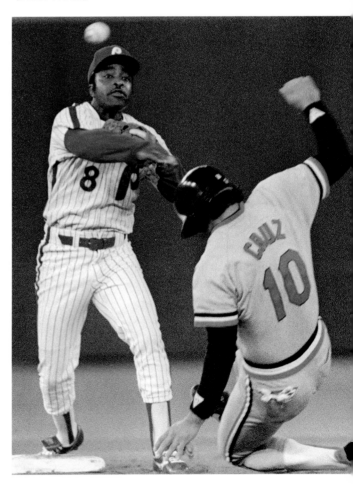

Johnny Bench

CATCHER

Born: December 7, 1947; Oklahoma City, Oklahoma
Height: 6'1" Weight: 197
Threw right-handed, batted right-handed
Elected to the Hall of Fame in 1989

In the gifted company of such Hall of Famers as Roy Campanella, Yogi Berra, Bill Dickey, and Mickey Cochrane, Johnny Bench stands apart. Experts hail him as the best all-around catcher in baseball history.

Bench's heroics as a long-ball hitter—he set a career record for homers by a catcher (389 compared to Yogi Berra's 358)—earned him frequent headlines during his career, but he had his greatest value behind the plate, where he made tough plays look routine and routine plays look easy. Bench predicted in 1968 that he would be the first catcher to win Rookie of the Year honors. Then he did just that. He also captured the first of his 10 Gold Gloves that year. No other National League catcher has half that number. In the American League, Jim Sundberg, the Texas star of the late 1970s and early 1980s, with six Gold Gloves, is the closest to Bench. Bench was also twice named the National League's Most Valuable Player.

While he was often hailed for his quick reflexes and varied defensive skills, Bench himself felt his most important contribution came in working with his pitching staff. Bench's number-one goal was "to keep guys off base." That he deemed much more important than throwing out base runners.

"It's easy for me to spot an irregularity in a pitcher's motion," Bench said in his book, *From Behind the Plate*. "But not so easy for the pitcher. I'll tell him to follow through, to get his back into the pitch, or that he doesn't have to force anything."

Bench is often saluted for the defensive changes he helped to trigger. Following the lead of Randy Hundley of the Cubs, Bench popularized the one-handed style of catching, keeping his throwing hand behind his

Bench also excelled as a hitter. His 389 homers are the most ever by a catcher. *(Wide World)*

back, out of harm's way. And Bench was the first to use a protective helmet behind the plate.

Tall but able to crouch to the ground, Bench had huge but "soft" hands, quick reflexes, and a powerful throwing arm. Soft hands are vital. A good catcher receives the ball, takes it in; he doesn't go for it. Bench was the ultimate receiver. He put only his fingers into his mitt, not his whole hand, which gave him more flexibility in his wrist and improved the trapping action of the mitt's web.

Bench took the conventional glove of the time and, using a razor blade, stripped it of much of its

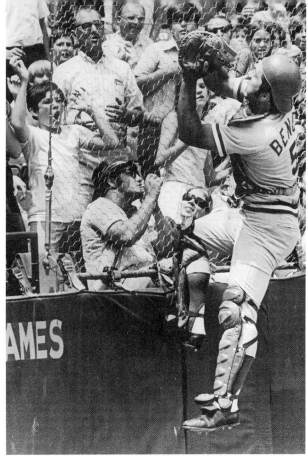

Right: Bench climbs the wall and screen behind home plate to haul in a foul pop. *(Wide World)*

Below: Bench tags out Chicago's Steve Ontiveros, who attempted to score from first on an outfield single. *(Wide World)*

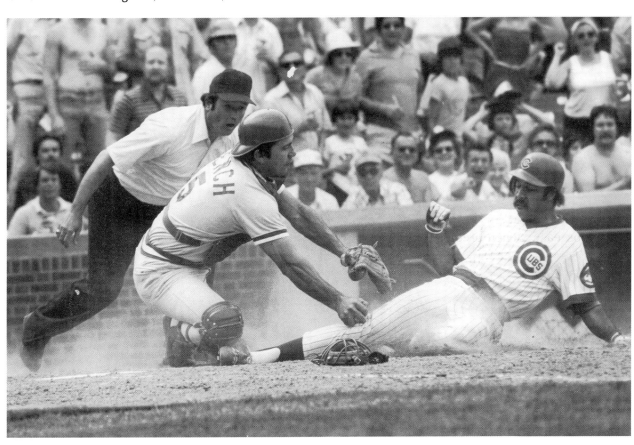

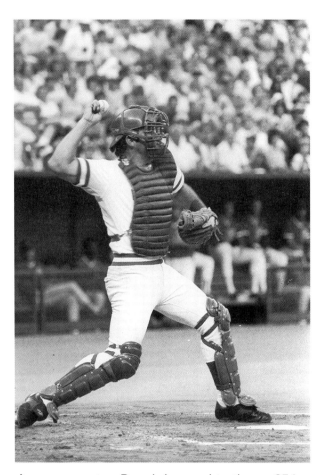

As a youngster, Bench learned to throw 254 feet on the fly from a crouch. *(Wide World)*

padding. With such a mitt, it was easier to take balls to his left or right and scoop them up from the dirt. "My glove automatically squeezed the ball," Bench once said. "With the old mitt, *you* had to squeeze. You became another infielder in the sense that the glove just closed around the ball if it hit in there."

Because of the glove's flexibility and because his massive hands were so relaxed, Bench could make catches that other catchers couldn't even attempt. He could actually pick balls out of the dirt backhanded.

The freedom of one-handed catching also helped to make Bench a master when it came to nailing base stealers. "I was doing all my movements to get into the cock position as the ball was

coming," Bench once said. "I didn't have to go out, play the ball, turn around, and get an extra step."

Raised in Binger, Oklahoma, Bench was the youngest of three boys of a former semipro catcher who later worked as a delivery-truck driver. He worked with young Johnny until the boy could throw 254 feet—twice the distance from home plate to second base—from a crouch. Besides catching, Johnny also played first base, third base, the outfield, and did some pitching. He batted .675 for Binger High School.

Immediately after graduation in 1965, Bench was taken in the second round of the free-agent draft by the Reds. He moved quickly through the Cincinnati farm system. After being named Minor League Player of the Year in 1967, he was promoted to the Reds.

The poised and confident Bench didn't hesitate in ordering veteran outfielders to shift their positions or telling pitchers what they were doing wrong. There was some resentment at first, but eventually the players learned to respect the young man's opinions.

In the years that followed, Bench became a vital cog in the "Big Red Machine," the nickname given to the powerful Cincinnati team of the 1970s. Between 1970 and 1976, the Reds won four pennants and two World Series. In the 1976 Series, the New York Yankees provided the opposition. The media spotlight focused on the rivalry between Bench and Yankee catcher Thurman Munson. Munson hit .529 and had two RBIs in the Series, which the Reds swept in four games. Bench hit .533, drove in six runs, and was named the Series MVP. "The man deserves all the credit in the world," Munson said after.

Bench believed he had the toughest position on the field. "The catcher has more things to do than anyone else," he said in *From Behind the Plate.* "You've got pop fouls to go after, back toward the screen. You almost always seem to be going toward a potentially dangerous stationary object

because almost any ball you go after is going to be out of play.

"Then you've got throws coming in to home and you've got to block the plate. And you've got to be able to field bunts, and call the game, and know the pitchers, and know the hitters, and block pitches in the dirt, and you've got to be able to throw out the runner trying to steal with a jump, and move the infielders and outfielders around, and try to keep up the pitcher's confidence."

The hard work didn't seem to bother Bench—in his early years. He set a record of catching 100 or more games for 13 consecutive years. But the injuries he suffered while catching—a broken thumb, fractured fingers, lower back spasms, six broken bones in one foot, and four in the other—took their toll. Toward the end of his career, he began to feel physically and mentally drained by his job. So it was that in 1980 he told the Cincinnati management that he would catch only two days a week. Most fans didn't like Bench's decision, and let him know it. Bench shrugged off the boos and stuck to his decision. He played 52 games at first base in the strike-shortened 1981 season and took over at third base the following year. He played 100 games in 1983 but was behind the plate for only 5 of them.

During this period, several of Bench's teammates, including Pete Rose, Joe Morgan, and George Foster, took the free-agent route to other teams. Not Bench; he remained in Cincinnati, where he owned two restaurants and a bowling center.

He announced his retirement in 1983. He went out in style, smacking a two-run homer on "Salute Johnny Bench Night."

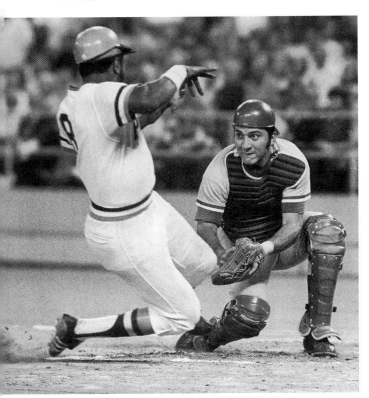

Bench gets set to put the tag on Pittsburgh's Willie Stargell in play at home plate. *(Wide World)*

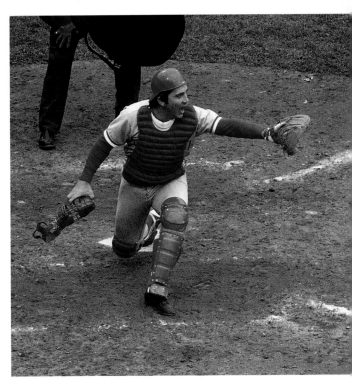

Twice the National League's MVP and the winner of 10 Gold Gloves, Bench has been hailed as the best all-around catcher in baseball history. *(Focus on Sports)*

Jim Kaat

PITCHER

Born: November 7, 1938; Zeeland, Michigan
Height: 6'4 1/2" Weight: 205
Threw left-handed, batted left-handed

Throughout his long and often glittering career, Jim Kaat had to listen to quips about his name (even though it was pronounced "cot," not "cat"). Jim Kaat has nine lives. Jim Kaat always lands on his feet. There's more than one way to skin a Kaat.

On the mound, the square-shouldered, six-four and a half left-hander, whose 25-year, 283-victory career with a number of teams ended in 1983, was said to be as quick as a cat. That happened to be true.

"Quickness helps you to knock the ball down," Kaat said. "What you want to do is not necessarily catch the ball cleanly but just knock it down. You'll have a good chance of making the play then."

Kaat's quickness, his intelligence, plus a thorough understanding of the league's hitters, helped to make him one of the best fielding pitchers in baseball history, perhaps *the* best. Kaat won 16 Gold Glove awards. Only third baseman Brooks Robinson won as many.

As a pitcher, Kaat had his best season in 1965, earning a 25-13 record for the Minnesota Twins. That year only one Cy Young trophy was awarded

for both leagues, and it went to Sandy Koufax of the Los Angeles Dodgers. But the *Sporting News* chose Kaat as the American League's "Pitcher of the Year."

As a youngster, Kaat worked not only on his pitching but on his hitting and fielding as well. "I wanted to be good in all phases of the game," he said. "I started working as a kid, throwing balls off the garage." Kaat's boyhood hero was five-foot, six-inch Bobby Shantz, a slick-fielding pitcher with the Philadelphia Athletics.

Kaat began his professional career at 19 as a pitcher for Superior (Wisconsin) in the Nebraska State League. He was 21 and pitching for Chattanooga in the Southern League when he was called up by the Washington Senators. When the Washington franchise shifted to Minnesota in 1961, Kaat went along. There he had several banner seasons, eventually winning 189 games for the team, which makes him the pitcher with the most wins in Minnesota Twins history.

Kaat was a 34-year-old junk pitcher with an 11-12 record in 1973 when the Twins sold him to the

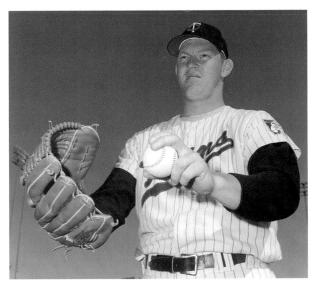

Kaat won 283 games during his career, 189 of them for the Twins, making him Minnesota's winningest pitcher of all time. *(Wide World)*

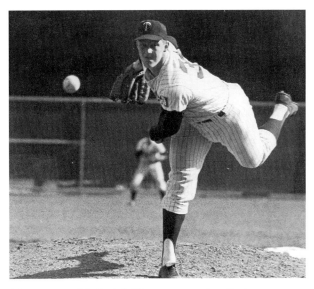

Kaat won 16 Gold Glove awards. Only Baltimore's Brooks Robinson won as many. *(Wide World)*

White Sox. In Chicago, Kaat was reunited with his former Minnesota pitching coach, Johnny Sain. In his first two full seasons with the White Sox, Kaat won 41 games, often using a quick-pitch delivery.

Kaat became a superior fielder somewhat out of necessity. He kept the ball in the strike zone, where it could be swung at. Thus he had to be ready to respond to a pitch that was likely to be coming right back at him.

Kaat's delivery brought him into a perfectly balanced position, ready to move in any direction. His long strides enabled him to hurry to either the right or left foul line in just two or three steps.

Kaat never stopped studying batters, learning their tendencies. He knew the players who were likely to bunt, and those who weren't. He knew the pull hitters, the ones that drilled the ball down the first or third baselines. "You pay even more attention to the contact hitters," he said. "They're the ones who are most likely to come up the middle."

In 1975, at the age of 37, Kaat was traded to the Phillies. Philadelphia then dealt him to the Yankees. He pitched relief in more games than he started for the Yanks, who sold him to the St. Louis Cardinals in 1980.

During his years with the Cards, manager Whitey Herzog also used Kaat as a reliever, not because he overpowered hitters but because he was so valuable as a fielder with men on base. In the case of a sacrifice bunt, a hit-and-run, or any ground ball, Herzog knew he could depend on Kaat to make the play.

Kaat retired as a player in 1983. Afterward, he used his knowledge of the players and the game, plus a willingness to carefully study and analyze, to launch a successful career as a baseball broadcaster.

Brooks Robinson

His eyes glued to the ball, Robinson hurries to his left to glove a bouncer off the bat of Yankees' Tom Sturdivant. *(Wide World)*

THIRD BASE

Born: May 18, 1937; Little Rock, Arkansas
Height: 6'1" Weight: 180
Threw right-handed, batted right-handed
Elected to the Hall of Fame in 1983

To Baltimore fans, he is the greatest player ever to wear an Oriole uniform, and for many baseball observers he ranks as the best third baseman in history. No player so completely dominated the position.

Robinson, who became a broadcaster in Baltimore following his retirement in 1977, rewrote the record book during his 23-year career. He played in more games, made more assists and putouts, handled more chances, and started more double plays than any third baseman in history. He won 16 Gold Gloves during his career, more than any other infielder.

But Robinson's statistical preeminence scarcely suggests his absolute wizardry, his ability to suck up every ground ball or line drive hit in his general direction. Very few players get to hear themselves described as the greatest at his position in the history of the game while they're still playing. Brooks Robinson did. He earned praise on a daily basis. During his stunning performance in the 1970 World Series, the opposing Cincinnati manager, Sparky Anderson, said, "I'm beginning to see

Brooks in my sleep. If I dropped this paper plate, he'd pick it up on one hop and throw me out at first."

Robinson's arm was no better than average but he had an exceptionally quick release and threw with tremendous accuracy. He wasn't particularly fast on his feet but he had razor-sharp reflexes.

As a high school basketball player, Robinson was an outstanding rebounder. It wasn't because

of his height; he was under six feet. It wasn't because of his ferocity; he was a bit laid-back, in fact. But what Brooks had was an "instinct" for the ball. He had the talent, he said, "to jump neither too soon or too late."

At 18, Brooks signed with the Orioles as a second baseman, but he soon realized that he wasn't fast enough to cover all the ground the position demands. Moving to third better suited his skills. In four of his first five seasons, he was shunted between the minor leagues and the majors. This was partly because he didn't impress anyone with his hitting, giving little hint of the home run potential or the clutch RBIs for which he later would become noted. Not until 1959, when he started gripping the bat down at the end and lengthened his swing, did his prowess at the plate begin to show.

But from the very beginning he was revered for his fielding—darting to his left, backhanding smashes down the line, and dashing in for bunts and slow rollers, making the pickup and the throw with one sweeping motion. Early in his career, when Baltimore manager Paul Richards sought to bench Robinson during a hitting slump, the Oriole pitchers protested. "They wanted him in there," Richards said. "They didn't care if he ever got a hit."

Robinson performed brilliantly throughout the 1960s, winning the American League's Most Valuable Player Award in 1964. But his career didn't begin to assume legendary dimensions until the 1970 World Series. It has come to be called the

At the plate, Robinson was noted for his clutch RBIs. *(Wide World)*

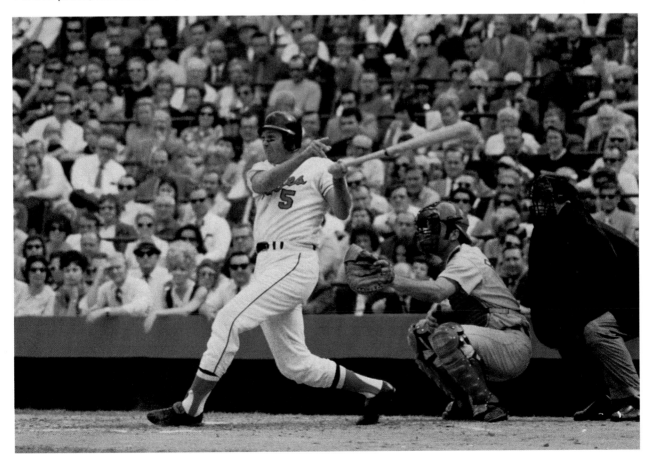

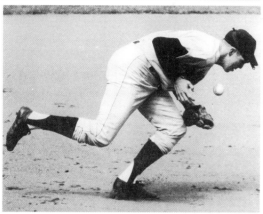

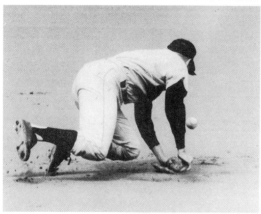

Brooks Robinson Show. The Orioles turned back the Cincinnati Reds in five games and Robinson was afire almost from the opening pitch.

In the first game, he made several outstanding plays, including a seemingly impossible backhand stop of a bullet off Lee May's bat to keep the go-ahead run off base. Then, with the score tied at 3-3 in the seventh inning, he homered to give the O's a 4-3 lead and, two innings later, the win.

In the first inning of the second game, Robinson turned what looked to be a sure double down the line into a force out. In the third inning, he converted another down-the-line shot into a third-to-second-to-first double play. He also knocked in the game-winning run in a 6-5 squeaker.

Robinson made several more dazzling plays in the third game. He turned Tony Perez's high bouncer over third into a double play. He charged Tommy Helms's slow roller down the line and threw him out at first. He made a diving catch to his left to grab a line drive off the bat of Johnny Bench.

Robinson went four-for-four in Game Four. In the fifth game, he made the most talked about play of the Series, a diving catch to his right—into foul territory—to take another hit away from Johnny Bench. Said Bench after, "I'll become a left-handed hitter to keep the ball away from that guy."

To say that Robinson was popular was to understate the case. "Other stars had fans. Robinson had friends," Tom Boswell of the *Washington Post* once observed. Sportswriter Gordon Beard said, "He never asked anyone to name a candy bar after him. In Baltimore, people named their *children* after him."

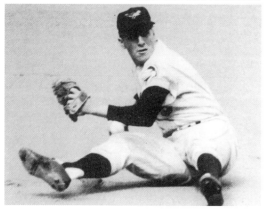

Robinson lunges to glove a line drive hit by New York's Bobby Richardson, juggles it momentarily, then recovers to make the throw from a sitting position to nail Richardson.
(Wide World)

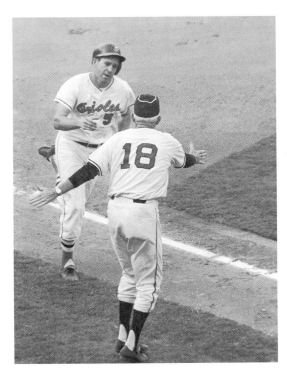

When Robinson retired in 1977, the Baltimore club held a day in his honor. The event drew the largest regular-season crowd in the history of Memorial Stadium. They stood and cheered for a quarter of an hour as Brooks, standing in the back of a Cadillac convertible, circled the field.

"Never in my wildest dreams did I think I would be standing here . . . saying good-bye to so many people," said Robinson when he took the microphone. "For a guy who never wanted to do anything but put on a major-league uniform, that good-bye comes tough. . . . I would never want to change one day of my years here. It's been fantastic."

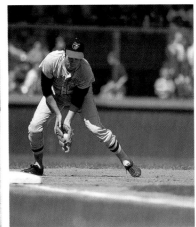

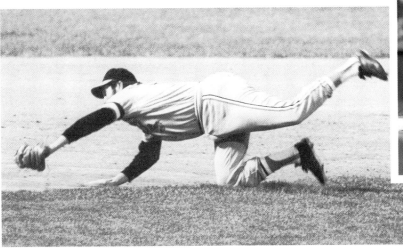

Above: Rounding third base, Robinson gets a congratulatory handshake after hitting a home run in 1967 All-Star Game. *(Wide World)*

Middle: Robinson springs to his right to glove a hot grounder. His throw to first was in time for the out. *(Wide World)*

Middle right: During his 23-year career, Robinson established himself as the best third baseman in baseball history. *(Focus on Sports)*

Right: Robinson spent a record 23 years with one team, the Orioles. Here he waves his cap to fans in Minnesota after it was announced that he was retiring. *(Wide World)*

Luis Aparicio

SHORTSTOP

Born: April 29, 1934; Maracaibo, Venezuela
Height: 5'9" Weight: 160
Threw right-handed, batted right-handed
Elected to the Hall of Fame in 1984

Not big, only five-foot-nine, 160 pounds, and seldom better than a fair hitter, Luis Aparicio got to the major leagues strictly on his speed and fielding ability. He made plays regularly on the right-field side of second base and he could also range far into left field and left-center to snare fly balls. And he introduced the one-handed style of fielding grounders, which is standard practice today.

His speed was amazing. He was super fast, not just in the field but on the base paths, too. He simply exploded off the mark, achieving flank speed in the blink of an eye. While Maury Wills, with a record 104 steals in 1962, is usually given credit for establishing the stolen base as an offensive weapon, Aparicio showed years earlier that thievery could pay. Beginning with his rookie season of 1956 (when he won Rookie of the Year honors), Aparicio led the American League in stolen bases for nine consecutive years. A fixture in the leadoff spot for the White Sox, Aparicio once stole successfully on 26 consecutive tries.

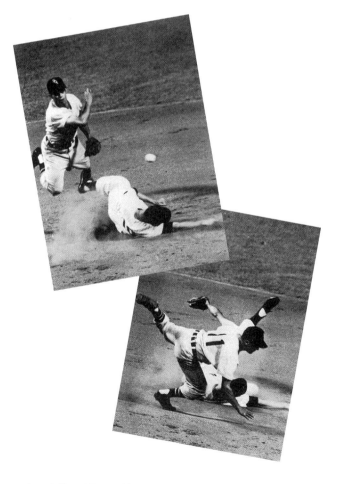

Avoiding Tony Kubek's hard slide, Aparicio gets away a leaping throw to double up Mickey Mantle at first base. *(Wide World)*

In the field, Aparicio combined his speed with sure hands and a remarkably strong arm. He earned nine Gold Glove Awards, more than any other American League shortstop.

The Venezuelan-born Aparicio was taught the ins and outs of baseball by his father, who was regarded as Venezuela's best shortstop. In a game at Maracaibo in 1953, when Luis was 19, play was halted and the elder Aparicio handed his glove over to his son and embraced him. So began Luis's career as a professional.

After Luis signed with the White Sox, he spent two years in the minor leagues. Quoted in *Nine Sides of the Diamond* by David Falkner, Al Lopez, manager of the Chicago team when Aparicio arrived upon the scene, appraised the young man's skills: "At shortstop, you must pick up the ball clean or you don't throw the man out. First, second, third, you can knock the ball down. At third, you don't need good hands. At second you don't need good hands or a good arm. At first all you need to be able to do is catch the ball. Shortstop requires the most ability: catching, arm, hands, experience. Luis has great hands, great arm, great speed. He covers ground from all angles, positions. I've seen some great shortstops, but he does everything well."

While with the White Sox, Aparicio was fortunate to be teamed with second baseman Nelson Fox. Together they made one of the outstanding double-play combinations in baseball history. When Fox was named the American League's Most Valuable Player in 1959, Aparicio was right behind him in second place.

Early in 1963, the White Sox broke up that double-play combination by dealing Aparicio to the Orioles. He was a big help in 1966 when Baltimore won the pennant and the World Series. Beginning in 1971, Aparicio spent three years with the Boston Red Sox.

In his 18-year career, Aparicio played shortstop in 2,581 games, more than any other American Leaguer in history. He led the league in fielding percentage eight times, assists seven times, putouts four times, and double plays twice. Aparicio once said that his fielding success stemmed from the fact that he used a heavier glove during infield practice to make his own feel lighter during the game. Surely, it must have been something more than that.

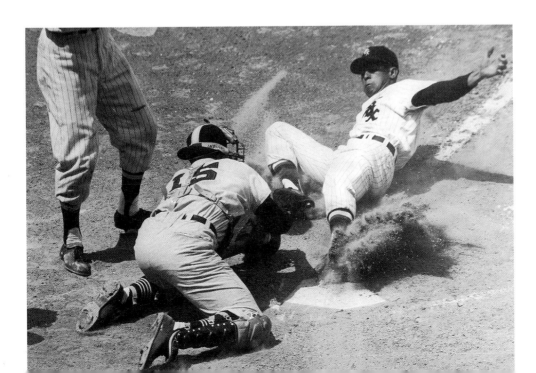

The speedy Aparicio was a constant base-stealing threat. But here he is tagged out by Cleveland's Russ Nixon in an attempt to steal home.
(Wide World)

Willie Mays

CENTER FIELD
Born: May 6, 1931; Westfield, Alabama
Height: 5' 10 1/2" Weight: 170
Threw right-handed, batted right-handed
Elected to the Hall of Fame in 1979

It's often called the greatest catch of all time. The fact that it came at the crucial point of an important game—the first game of the 1954 World Series—made it even greater still.

The New York Giants faced the Cleveland Indians, who had won 111 games that year to establish an American League record. (Only the 1906 Cubs, with 116 victories, had ever won more.) The Indians were heavily favored over Leo Durocher's Giants, despite the presence of Willie Mays, who, with a .345 average, had been crowned the National League's batting champion.

In the first inning of Game One at the Polo Grounds in New York, Vic Wertz tripled with two men on base to give the Indians a 2-0 lead. Hank Thompson's single drove in two runs in the bottom of the third to tie the game. It was still tied when Cleveland center fielder Larry Doby walked to open the eighth inning. Al Rosen then followed with an infield hit, bringing Wertz to the plate again.

Wertz had singled in addition to his triple. With that in mind, manager Durocher waved in Don Liddle from the bullpen.

Wertz smashed Liddle's first pitch toward deep center field in what was one of the most spacious center fields in baseball. Mays, who was playing shallow, as he usually did, turned and raced for the wall, his back to home plate. Moving at full speed, he reached out, extending both hands, and the ball plunked into his glove.

The best was yet to come. Mays planted his right leg, turned toward the plate, his eyes looking back at the infield, then threw in one powerful motion. The throw held Doby at second. Liddle got the next two batters, and the Giants, instead of trailing, 4-2, were still alive. The New York team won the game in the tenth inning and went on to sweep the Series in four games.

"I knew that I had that ball all the way from the time it left Wertz's bat," Mays said later. "I could see the ball as soon as it left the bat, I got a good

jump on it. But what a lot of people forget about the catch was that I had to make a throw on it because there were two men on base who could have moved up after I caught it. That was the toughest part of the play."

In the summer of 1951, Ed Fitzgerald, the editor of *Sport* magazine, took a subway to the Polo Grounds to interview Mays, then a rookie sensation with the Giants. He titled the story "Amazin' Willie Mays."

He was certainly amazin' that year, winning Rookie of the Year honors. He was still amazin' in 1954 after he returned to the Giants following two years of army service. He was amazin' for the rest of the 1950s and all through the 1960s.

Amazin' Willie Mays was a "complete player"— he could hit for average, hit with power, and steal bases. When it came to fielding, he could chase down about anything in the ballpark, and he threw brilliantly. "He could just run like the wind and throw like hell," pitcher Robin Roberts once said of him. Mays won 12 Gold Gloves for his play in center field. Roberto Clemente is the only other outfielder to have won as many.

Mays's catch in the 1954 World Series—sometimes referred to simply as The Catch—is generally ranked as his best, but there were others that came close or might even have surpassed it. In a game in San Francisco's Candlestick Park in 1970, Mays, then with the Giants, collided with teammate Bobby Bonds near the top of the chain-link fence in right-center field. Mays was close to unconscious when he fell to the ground, but he managed to hold on to the ball for the out.

Mays also drew cheers with his powerful arm. He once recalled a game against the Kansas City Monarchs when he was still in his teens and playing in the old Negro National League for the Birmingham Barons. Mays threw out two base runners, one trying to leg it from first to third on a single past the shortstop, the other attempting to score from second on a base hit to right-center.

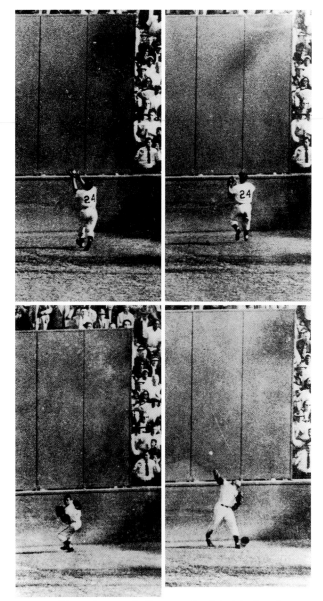

Above: Running at full speed with his back to the plate, Mays catches Vic Wertz's long drive, then brakes hard and turns to make the throw, holding the runner at second. *(Wide World)*

Then a third opportunity loomed. But Buck O'Neill, the manager of the Monarchs, coaching at third, halted the runner as he came into the base on a single to center, yelling out, "Whoa, that man's got a shotgun!"

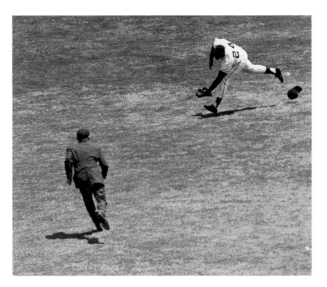

Above: **Mays makes an exciting shoestring catch to rob Chicago's Ernie Banks of a base hit.** *(Wide World)*

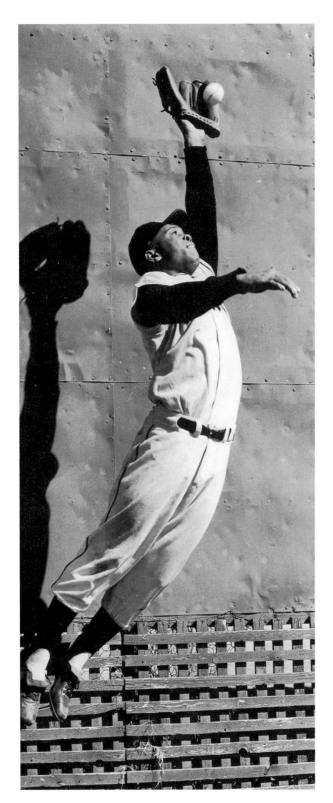

Mays goes high to glove a ball near the outfield fence at the Giants' training facility in Phoenix, Arizona. Photograph is from 1956, Mays's fifth year with the team. *(Wide World)*

Mays's most distinctive maneuver in the field was his "basket catch," which he picked up in the army. Mays was startled the first time he saw an army teammate who, as Mays once described it, "thought the way to catch a fly ball was to hold his glove like he was taking out an old railroad watch to look at it." But once Mays tried catching the ball at waist level, he liked it. "I could never be off balance that way," he said.

The basket catch not only made good sense, it was an example of Mays's showmanship. Letting his cap fly off his head as he chased down a fly ball was another of his trademarks. So was his daring baserunning. And Mays was the first ballplayer to have his uniform tailored so it fit like a coat of paint.

What was perhaps Mays's greatest challenge as an outfielder came in 1958, after the Giants had moved to San Francisco. There Willie was confronted with the tempestuous winds of Candlestick

Park. It took time, but eventually Willie learned the "secret" for playing the outfield at Candlestick (which he didn't reveal until his playing career had ended). Patience was the key. "When the ball was hit, I didn't move," he said. "From the moment it was up in the air, I started counting to five—one, two, three, four, five. At five, I'd begin to run."

Mays was traded back to New York—to the Mets—in 1972. He played only one season with the Mets. He later returned to the Giants as a coach.

In a 22-year career, Mays played 2,992 games of baseball, not counting playoffs or the World Series. He won two MVP Awards. He was named Player of the Decade by the *Sporting News* in l969. *Sport* magazine, celebrating its twenty-fifth anniversary in 1971, named Mays baseball's top player during those 25 years. At the time of his retirement in 1973, on the all-time charts, Mays ranked fourth in runs, third in hits, third in home runs, and seventh in RBIs. He led National League

outfielders in double plays four times and set records for career putouts and total chances. In 1999, when baseball experts are selecting their 50-year all-star teams for the year 2000, Willie Mays is certain to be everyone's choice in center field and is sure to get more than a few votes as the best player of the previous half century.

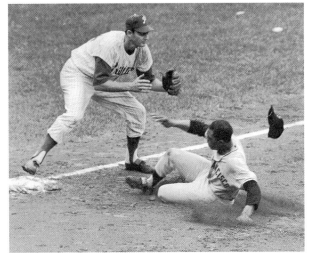

Right: Mays slides into third base and, in typical fashion, loses his hat. *(Wide World)*

Below: At Ebbets Field in Brooklyn, Mays leaps high to grab a line drive from the bat of Duke Snider. *(Wide World)*

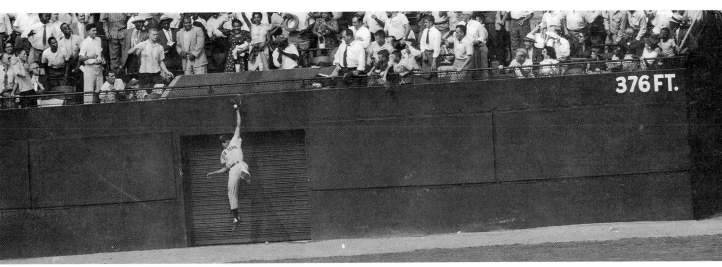

376 FT.

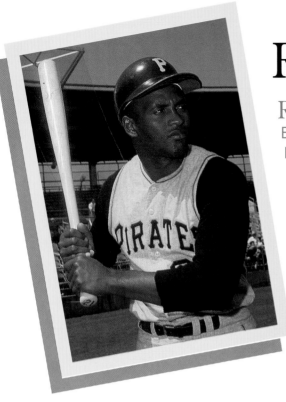

Roberto Clemente

RIGHT FIELD

Born: August 18, 1934; Carolina, Puerto Rico
Died: December 31, 1972
Height: 5' 11" Weight: 175
Threw right-handed, batted right-handed
Elected to the Hall of Fame in 1973

After a long run, and while falling, Clemente succeeds in snagging a fly off of the bat of Cleon Jones of the Mets. *(Wide World)*

In July 1971, not long before his thirty-eighth birthday, Roberto Clemente made what might have been the most spectacular catch of his career. In the eighth inning of an important game against the Houston Astros at the Astrodome, Clemente's Pittsburgh Pirates were leading, 1-0. The Astros' Bob Watson laced a long drive toward the right-field corner. Clemente went after it, running with his back to the plate. As he neared the wall, he twisted his body and leaped high, his fully extended glove reaching beyond the Astrodome's bright yellow home run line. At almost the same moment that the ball plunked into his glove, Clemente's body slammed into the wall. When he got up, still clutching the ball, the left side of his body was bruised and bleeding at the elbow, knee, and ankle.

"A great catch is one that saves a game," Clemente said afterward. (Clemente's catch saved the game.) "It's just like a home run. It doesn't make any difference if it's a short one or a long one if it wins the game."

Perhaps the best right fielder in baseball history, Roberto Clemente went for balls off fences and walls, hard or soft. He pioneered the sliding-on-the-stomach and skidding-on-the-hip catches. "Somebody would hit the ball against us," teammate Manny Sanguillen once recalled, "and we'd say, 'It's gone.' We didn't know that Clemente was running. Then he'd go *poom!* against the fence and he'd catch the ball. I don't know how he did it."

Clemente's arm was powerful and deadly accurate. He threw people out at the plate from the warning track at the Pirates' Forbes Field, a distance of 350 feet. Trying to take an extra base on him was usually costly. In 1958, he threw out 22 runners to capture the first of his five assist titles. He won 12 consecutive Gold Gloves.

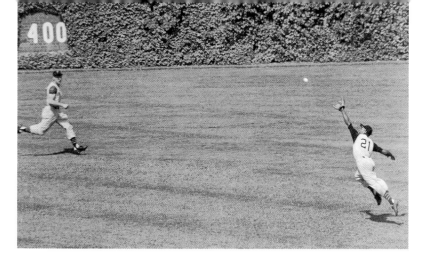

Above: Clemente lunges to his right to make a sensational back-handed catch of a long drive by Chicago's Bobby Thomson. *(Wide World)*

Right: Clemente is greeted by his teammates after a home run against the Dodgers in Los Angeles. *(Wide World)*

Born in Puerto Rico, Clemente played for Santurce in the Puerto Rican Winter League while still in high school. He quickly attracted the interest of major-league scouts. Signed by the Brooklyn Dodgers for a $10,000 bonus, he was left unprotected in the 1954 draft and was grabbed by the Pirates for $4,000.

It proved to be one of the club's great investments of all time. Clemente joined the Pittsburgh outfield in 1955 and remained for 18 seasons. He was a wicked line-drive hitter with sprinter's speed, and his outfield exploits soon became legendary. He hit over .300 in 13 seasons, won four National League batting titles, and had a lifetime .317 average. He won MVP honors in 1966 and was an All-Star selection 12 times.

After Clemente helped lead the Pirates to National League championships in 1960 and 1971, he starred in both World Series. He hit safely in every Series game in which he played. In the 1971 Series, Clemente batted .414, homered in the sixth and seventh games, and fielded flawlessly. No one was surprised when he was named the Series MVP.

Through much of his career, Clemente was plagued with pain. When he swung and missed a pitch, his back often hurt so much that he would wince and drop the bat, then reach over slowly to pick it up again. He was also bothered by tension headaches, a nervous stomach, bone chips in one elbow, and insomnia.

Injuries hampered Clemente in 1972 but his batting average only fell to .312. In his final game that season, he banged out his 3,000th hit, becoming only the eleventh player in history to reach that level. Afterward, he returned to Puerto Rico, where he reigned as a national hero.

In December that year, an earthquake devastated Managua, the capital of Nicaragua. Clemente, who helped organize a relief effort, died in a plane crash carrying food and medical supplies to the stricken city.

The usual five-year waiting period was waived and in 1973 Clemente was voted into the Hall of Fame. He later became the second baseball player—Jackie Robinson was the first—to be pictured on a United States postage stamp.

Bill Mazeroski

SECOND BASE
Born: September 5, 1936; Wheeling, West
Virginia
Height: 5' 11 1/2" Weight: 183
Threw right-handed, batted right-handed

Mention Bill Mazeroski's name and baseball fans think of the 1960 World Series and the monumental home run he hit against the New York Yankees that gave the Pittsburgh Pirates the championship. Deadlocked at three games apiece, the two teams met for the finale at Forbes Field in Pittsburgh. The Yankees rallied for two runs in the top of the ninth to tie the game, Mazeroski was the first of the Pirates to face Yankee reliever Ralph Terry in the bottom of the ninth. Terry threw an inside pitch to Mazeroski, who lashed it over the left-field wall.

Besides that dramatic home run, Mazeroski had plenty of other achievements. Most of them involved his slick fielding. Every move was lightning fast. He was called "No touch" and "No hands" because of the speed of his relay tosses to second on double plays.

The winner of eight Gold Glove Awards, Mazeroski led the National League in assists for nine years and double plays for eight years. Both are records. He took part in 1,706 double plays during his 17-year career, another record. Few *first*

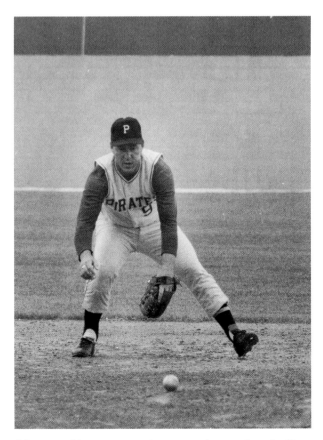

Mazeroski concentrates on a bouncing ball during a workout at Pittsburgh's Lakeland, Florida, training base in 1968. *(Wide World)*

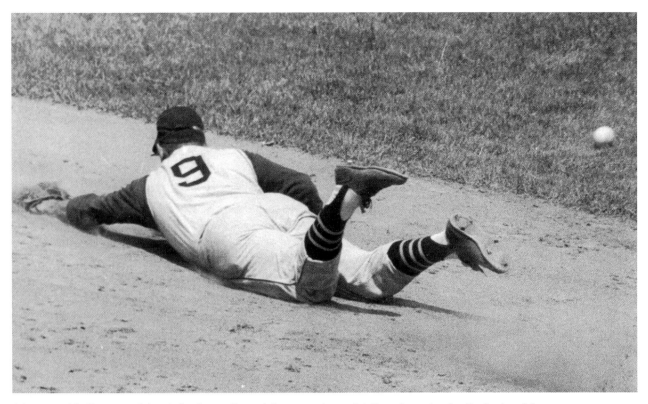

Mazeroski dives to his right for a line drive up the middle—but the ball eludes him. *(Wide World)*

basemen have figured in that many double plays, and they are usually at the receiving end of one.

Mazeroski was also a league leader in courage. When acting as a pivotman, with the runner barreling toward him, Mazeroski was always cool. He took no extra step to avoid getting leveled. He hung in there. Getting the throw away was what was important to him.

Mazeroski signed with Pittsburgh in 1954 and was assigned to Williamsport in the Eastern League. Hollywood in the Pacific Coast League was his next stop. In 1956, he joined the Pirates for 81 games. For the next dozen seasons, he was a full-time player for the team. Seven times he was elected to the National League's All-Star team.

Mazeroski's historic home run in the 1960 World Series caused people to forget some of his other Series heroics. In Game One, he hit a homer in the first inning and turned three double plays, the third of which ended the game. He had a .320

batting average for the Series, with 8 hits in 25 at bats.

In 1961, Mazeroski participated in 144 double plays, a National League record for second basemen. In 1966, with 161 double plays, he established the record for both leagues.

The Pirates were back in the World Series in 1971 (and beat the Orioles in seven games), but Mazeroski was a part-time utility player by that time. Mazeroski retired in 1972. He later became an infield instructor for the Montreal Expos. But he was back in Pittsburgh in 1987 for ceremonies at Three Rivers Stadium in which the Pirates retired his number 9.

Bobby Shantz

PITCHER

Born: September 26, 1925; Pottstown, Pennsylvania

Height: 5'6" Weight: 139

Threw left-handed, batted right-handed

When major-league scouts scour high school or college diamonds for pitching prospects nowadays, they're looking for rangy, muscular six-footers, young men who burn the ball across the plate at speeds beyond 90 miles an hour. Bobby Shantz would be out of luck today. He had no blazing fastball and when he graduated from high school in 1943, he was 4-foot-11 and weighed 110 pounds. Coaches kidded him about being a midget.

But Bobby Shantz used sharp-breaking curves, an occasional knuckler, and pinpoint control to scratch out a 16-year career in the majors, playing for several teams. Besides effective pitching, Shantz was perhaps baseball's best fielding pitcher of the past half century or so. He won eight Gold Gloves but conceivably could have won twice that number. The Gold Glove Award wasn't established until 1957, and by that time, Shantz had already been pitching for eight years.

Efficient was the word often used to describe Shantz's delivery. He used a short, quick stride with a minimum of leg kick. It brought him into a balanced position, ready to field any line drive, grounder, trickler, or bunt. He believed his size was also a factor in his fielding success. "Because I was so small," Shantz once told an interviewer, "I had to put everything into the pitch and because of that I had to be doubly sure I was ready to field."

When Shantz was on the mound, he was a sixth infielder, eager to play every ball he could reach. His first baseman and third baseman could thus play a little bit deeper, while his second baseman and shortstop could position themselves more toward the holes.

Besides his ability at fielding balls, Shantz was a master at backing up bases. On a hit to the outfield, he'd wait, linger in between home and third until he knew where the throw was going, then race for the appropriate base.

Shantz was deadly on bunts, too, coming off the mound like an express train to glove the ball or seize it bare-handed. "Anyone who bunts against Shantz is nuts," said Jimmy Dykes, manager of the Philadelphia Athletics, Shantz's first major-league team.

Once asked to name his best fielding play,

Shantz's delivery brought him to a balanced position, ready to field any line drive, ground ball, or bunt. (National Baseball Hall of Fame and Library)

season of semipro ball followed before the Philadelphia A's signed him. Then he pitched in the minor leagues for a year before he was given his chance in the majors. In his big-league debut, coming in as a reliever, Shantz pitched a full 9 innings of no-hit ball to beat the Detroit Tigers, 5-4, in 13 innings.

The 1952 season was Shantz's best. He ended with a 24-7 record and was the league MVP. But late in the season, his left wrist was broken in two places by a wicked fastball. Shantz wasn't an effective pitcher again until after he was traded to the Yankees in 1957. He helped the New York team win pennants in 1957, 1958, and 1959. Shantz was with his eighth ball club, the Phillies, when he retired in 1964.

New York manager Casey Stengel was once asked to explain the reasons for Shantz's success. The addition of the knuckleball to his repertoire was a key factor, Stengel said. "Before he had the knuckler down cold, he used to throw the fastball too much." Then Stengel added, "Hit? The little guy's a great hitter. Bunt? Best in the league. And he's the greatest fielder in baseball, bar nobody."

Shantz picked a bunt attempt. Phil Rizzuto of the Yankees was the victim. Rizzuto was one of bunting's all-time greats. He would tuck the bat behind his front shoulder, concealing it from the pitcher, then quickly drop it on the ball. Against Shantz, he worked the play to perfection, nudging the ball down the third-base line. Just as it dribbled to a stop, Shantz got to it, picked it up bare-handed, whirled, and threw him out. "It was the best fielding play I ever made," Shantz said.

The son of a Pottstown, Pennsylvania, semipro player, Shantz first made his mark at 19 as a pitcher in Philadelphia's Quaker City League, finishing with a 9-1 record. Also that team's cleanup hitter, he batted .485. Two years in the army and another

Bobby Shantz (right) and his brother Billy, a catcher, were Yankee teammates briefly in 1960. *(Wide World)*

Richie Ashburn

CENTER FIELD

Born: March 19, 1927; Tilden, Nebraska
Height: 5' 10" Weight: 170
Threw right-handed, batted left-handed
Elected to the Hall of Fame in 1995

What was perhaps Richie Ashburn's greatest moment as a member of the Philadelphia Phillies came on the last day of the 1950 season. The Phillies, leading the Dodgers by only a game, faced the Brooklyn team at Ebbets Field. With the score tied, 1-1, in the last of the ninth and Cal Abrams on first base for the Dodgers, Duke Snider lashed a single into center. Ashburn played the ball perfectly and rifled it to the plate, cutting down Abrams by 20 feet to stifle the Brooklyn rally. It wasn't even close. The play set the stage for Dick Sisler's tenth-inning homer that clinched Philadelphia's first pennant in 35 years.

In the Dodger dressing room after the game, Burt Shotton, the Brooklyn manager, asked, "How could Ashburn dare to play so close? He never threw out a guy before." Shotton was dead wrong, of course. Ashburn had thrown out seven other runners at home plate that season. Because of his speed in getting to the ball and his quickness in making the throw, it was always risky attempting to take an extra base on him.

Richie Ashburn was 18 when, in the spring of 1945, he reported to the Philadelphia farm club at Utica, New York, in the Eastern League. He looked forward to making the team as a catcher, the position he had played in high school back in Tilden, Nebraska. But one day the team ran out of outfielders and manager Eddie Sawyer asked Ashburn to help out. He was a center fielder from that day forward.

In 1948, after a tour of duty in the army and another season at Utica, Richie was invited to the Philadelphia spring training camp. To win the job in center field, all Richie had to do was beat out Harry "the Hat" Walker, who had been the National League's batting champion the previous season. One morning Walker fouled a pitch off his foot and was out of the lineup. By mid-May, when Walker was ready to return, Ashburn was hitting .346 and playing center field like he invented the position. He was the only rookie on the 1948 All-Star team and he was named Rookie of the Year.

Ashburn's statistics are evidence that he is one of the best center fielders of all time. He simply ran all over spacious center field at Shibe Park. In both total chances and total putouts, he ranks fifth behind Tris Speaker, Willie Mays, Ty Cobb, and Max Carey. And in chances per game, he's second behind Taylor Douthit, an outfielder with the Cardinals and Reds in the 1920s and 1930s. Ashburn averaged 3.0 chances per game; Douthit, 3.2.

There's more. Ashburn set records by recording 500 or more putouts in four different seasons and 400 or more putouts in another four different seasons.

A pesky line drive hitter, Ashburn compiled a lifetime average of .308. *(Wide World)*

Ashburn was no slouch as a hitter, either. In his 15-year career, he won the league batting championship twice and compiled a .308 lifetime average. Always pesky at the plate, Ashburn led the league in bases on balls four times, too.

Ashburn was traded to the Cubs in 1960. From Chicago he went to the Mets in 1962, the first year of the team's existence. When he was named as the expansion team's first All-Star, it marked the fifth time he had been named to the All-Star squad. After his retirement as a player at the end of 1962, Ashburn enjoyed a long career as a Phillies broadcaster.

Left: Ashburn snags a long drive from a fan's grasp at the Philadelphia training facility at Clearwater, Florida. *(National Baseball Hall of Fame and Library)*

Mickey Vernon

FIRST BASE

Born: April 22, 1918; Marcus Hook, Pennsylvania
Height: 6'2" Weight: 170
Threw left-handed, batted left-handed

Mickey Vernon was the classic first baseman. He offered a big target, was able to stretch, and was very agile. He was also alert and intelligent on the base paths and a line-drive power hitter, twice winner of the American League batting championship. Who could ask for anything more?

It also happened that he was the favorite player of Dwight D. Eisenhower, whose first term in the White House occurred at the same time as Vernon's second tour of duty with the Washington Senators. Once, during the season of 1954, after Vernon had hit a game-winning home run at Griffith Stadium, Eisenhower asked his Secret Service agents to escort the lanky first baseman to the presidential box so he could offer personal congratulations.

While he had tremendous range in the field, Vernon wasn't known for his flashy footwork. Keep it simple; don't get fancy. That was Vernon's way. He'd get to the bag in a hurry and let the direction of the throw dictate what he'd do. Because he was a left-handed thrower, most of the time he'd keep his left foot against the bag and stretch with his right.

What was important to Vernon was how he positioned his left foot. "If a ball went to the home-plate side of the bag, then, naturally, you'd take that corner," he said. "If it came from the second-base side, you'd take it from *that* corner."

But Vernon would switch feet if he had to—if, for example, there was a throw far off the base and into the dirt, or if he had to leap high to make a catch, knowing he was going to have to make a tag to get the out.

James Barton Vernon, nicknamed Mickey by an aunt at the age of 3, was 19 and had played a year of college baseball at Villanova when he signed with the Washington Senators in 1936. He made slow but steady progress through the minor leagues, arriving with the Senators to stay in 1940.

His great mobility helped to make Vernon an outstanding major-league first baseman. His hitting was something of a bonus for the team. After spending 1944 and 1945 in the military, he returned to hit .353 and capture the American League batting crown. He won the title again in 1953 with a .337 average. Three times he led the league in doubles and he had almost as many triples in his career as Willie Mays had (120 to 140).

In the course of his 20-year career, Vernon compiled some impressive statistics. He played more games at first base than "Iron Horse" Lou Gehrig (2,237 to 2,136). In fact, only two players in all of baseball history played more games at first: Jake Beckley, a turn-of-the-century player, and Cleveland's Eddie Murray. Vernon ranks first in double plays (with 2,044), sixth in putouts (19,808), seventh in chances (21,467), and fourth in assists (1,448).

Vernon never won election to the Hall of Fame and he gets beaten out by Lou Gehrig, George Sisler, or Hank Greenberg on most all-time all-star team selections. Perhaps this is because Vernon spent most of his years with the Washington Senators, who seldom challenged for the pennant. In the final stages of his career, he served as the jewel on an assortment of other lackluster teams. Whatever the reason, Mickey Vernon deserves better.

Left: Vernon leaps high to snare a high throw during team spring practice session at Tampa, Florida. *(Wide World)*

Right: Vernon lets out a yell as he puts the tag on Chicago's Jim Busby, picking him off first base on a throw from pitcher Conrado Marrero. *(Wide World)*

Roy Campanella

CATCHER

Born: November 19, 1921; Philadelphia, Pennsylvania
Died: June 26, 1993
Height: 5' 9 1/2" Weight: 190
Threw right-handed, batted right-handed
Elected to the Hall of Fame in 1969

Smart and solid, an outstanding handler of pitchers, Roy Campanella—along with Jackie Robinson, Duke Snider, Gil Hodges, Pee Wee Reese, and Carl Furillo—was a member of the legendary "Boys of Summer," the Brooklyn Dodger teams that captured five National League pennants between 1949 and 1956. Although his exceptional career was cut short after 10 major-league seasons by a disastrous car accident, he led the league in putouts six times, caught three no-hitters, and won National League Most Valuable Player honors three times.

From the Nicetown section of North Philadelphia, Campanella was 24 when, in 1946, he became the second black player to be recruited by the Brooklyn Dodgers. But he had a wealth of baseball experience, having quit high school at the age of 15 to join the Baltimore Elite Giants, one of the best teams in the Negro National League. In addition, Campanella spent his winters playing baseball in the Caribbean and South America.

After a season with Nashua (New Hampshire) in the New England League, the Dodgers assigned Campanella to Montreal, then a minor-league team in the International League, in 1947, and he began 1948 at St. Paul in the American Association. Called up by the Dodgers in midseason, Campy was an immediate success. He made his first start in a doubleheader against the Giants and rapped out three hits, including a double and triple, in the first game, and two home runs and a single in the nightcap. He was equally impressive behind the plate. His debut was such that veteran catcher Gil Hodges was instantly switched to first base.

The stocky, muscular Campanella presented a compact target to pitchers and proved especially skilled at tagging runners sliding in from third base. He would offer a side of the plate to the runner; then, as he took the throw in a kneeling position, he would extend his left leg, forcing the sliding runner away from the plate.

In nine consecutive years, Campanella caught at least 100 games for the Dodgers per year, with a high of 140 in 1951 and again in 1953. He played despite battered fingers, knotted thigh muscles, and fatigue that bordered on exhaustion. In 1954, Campanella tried to play with a broken bone in his

wrist, but manager Walter Alston benched him in an effort to convince Campy that he needed surgery.

But in 1955, Campanella was back in form. He played in 123 games, hit .318, with 32 home runs, and helped lead the Dodgers to the pennant and a World Series victory over the Yankees. It was Brooklyn's first Series win ever.

That proved to be Campanella's last banner season. In the early hours of a January morning in 1958, Campanella was driving to his home on Long Island from a liquor store he owned and operated in Harlem. His car skidded on a sharp curve and slammed into a telephone pole. The accident left Campanella paralyzed from the waist down.

The following year, the Dodgers played an exhibition game against the Yankees at the Los Angeles Coliseum in Campanella's honor. A crowd of 93,103 turned out (and 15,000 were turned away), an all-time record for baseball.

A couple of important ifs can be applied to Campanella and his career. If it were not for the accident, he could well have become the first black manager in the majors. He had real leadership qualities and was especially well liked by his teammates. And if he had managed to stay healthy another three or four years, and continued to play at peak form or close to it, he well might be looked upon as the greatest catcher of all time.

At Ebbets Field, in close play at home plate, Campanella tags out Jack Lohrke of the Giants. *(Wide World)*

Marty Marion

SHORTSTOP

Born: December 1, 1917; Richburg, South
Carolina
Height: 6'2" Weight: 170
Threw right-handed, batted right-handed

When Marty Marion joined the St. Louis Cardinal organization late in the 1930s, he was called "Slats" because he was tall and toothpick thin. Later, when Billy Southworth was managing the club and enjoying Marion's brilliance on a day-to-day basis, he gave him another nickname— "Mr. Shortstop."

Marion was not a small but quick shortstop, like Phil Rizzuto and Pee Wee Reese, two of his contemporaries. Marion stood six-foot-two, yet despite his size he was very agile, able to dash deep into the hole between short and third, glove the ball, and gun down the runner. "Mr. Octopus" was yet another of his nicknames, given to him because his long arms snared so many balls that looked like surefire base hits.

Marion anchored the infield of the Cardinal teams of the 1940s, which included some of the best in club history. In 1944, when he was named the National League's Most Valuable Player, the honor was almost solely on the basis of his fielding ability. That had never happened before and it hasn't happened since. Marion hit .267 that year, with six home runs and 63 RBIs. Obviously, he didn't get many votes for his hitting.

Marion always seemed to perform at a peak during World Series play. In the fifth game of the 1942 Series between the Cards and the Yankees, with the Cards leading, three games to one, the Yankees rallied in the ninth, putting runners on first and second with no outs. As Johnny Beazley,

Above: In the spring of 1937, Marion (left) and infielder Frank Mabney posed for this photograph at the training camp of the minor league Rochester Redwings. Marion went on to a brilliant career with the Cards; Mabney never advanced beyond Rochester. *(Wide World)*

going for his second win of the Series, threw a fast-ball to catcher Jerry Priddy, the Yankees' Joe Gordon danced off second. The alert Marion cut behind Gordon to take catcher Walker Cooper's throw and put the tag on the Yankee second base-man as he slid back into the base. The pickoff play broke the back of the Yankee rally, and the Cards went on to win the game and wrap up the Series.

In 1944, Marion's MVP year, the Cards met their crosstown rivals, the St. Louis Browns, in what was called the Trolley Series. The underdog Browns won two of the first three games. In Game Four, Marion reached out to snare a ground ball over second base, what looked to be a certain base hit, and turn it into a fancy double play, which helped sink the Browns. The Cards went on to capture the Series in six games.

Through much of his 13-year career with the Cards, Marion played with a painful physical condition. When he was 12 years old and playing with friends near his home in Atlanta, he accidentally fell down a steep embankment and shattered his right thigh. He spent the next seven months in a plaster cast that extended from his chest to his knee. The mishap left him with frequent back pain and a right leg that was an inch shorter than his left.

The old injury eventually forced Marion to cut short his career. In 1949, he had to limit himself to 134 games; in 1950, to 106. Except for a few appearances at shortstop when he managed the Browns in 1952 and 1953, Marion's playing days were over.

Like several of the standout players who have held down what is perhaps the most demanding job in baseball, Marty Marion has yet to win election to the Hall of Fame. This could change, though. Shortstops have recently begun to get the recognition they deserve. Luis Aparicio and Pee Wee Reese were voted into the Hall of Fame in 1984, and Arky Vaughan in 1985. Phil Rizzuto won election in 1994. For Marty Marion's fans, there's still hope.

When Marion was named MVP in 1944, the selection was based almost exclusively on his fielding ability. *(National Baseball Hall of Fame and Museum)*

Joe DiMaggio

CENTER FIELD

Born, November 25, 1914; Martinez, California
Height: 6'2" Weight: 193
Threw right-handed, batted right-handed
Elected to the Hall of Fame in 1955

DiMaggio limbers up at the Yankee spring training facility at Ft. Lauderdale, Florida.
(Wide World)

It is said of Joe DiMaggio that he never made a difficult catch in center field; that is, he never made a catch *look* difficult. Away quickly and gracefully at the crack of the bat, he would glide under the ball and be there waiting for it as it came down. Or, as one fan is supposed to have said, "The son of a gun! Ten years I've been watching him and he hasn't had a hard chance yet."

DiMaggio threw with the same apparent ease, but his throws came in with tremendous speed and accuracy. At the plate, he stood with his feet spread wide, his bat cocked high. He strode only a few inches, yet he hammered the ball with awesome power.

Joe DiMaggio was the eighth of nine children of a San Francisco crab fisherman and his wife. Two others—Vince and Dom—also had big-league careers, but neither one came close to achieving "Joltin' Joe's" superstar status.

At 19, DiMaggio hit in 61 straight games in his first professional season with the minor-league San Francisco Seals, an all-time record for professional baseball. Bought by the Yankees in 1936, he

opened his career in right field but was switched to center when Ben Chapman was dealt to Washington. In his rookie season, DiMaggio hit .323, with 29 homers and 125 RBIs, and displayed speed, power, and a strong throwing arm.

In the World Series that year, he made one of his countless memorable catches in center field. The Yankees faced their local rivals, the Giants. In the second game, won by the Yankees, 18-4, Joe caught the final out in deep center field at the Polo Grounds after a long run, then raced up the clubhouse stairs without breaking stride.

In 1939, DiMaggio led the league in batting and won the first of three Most Valuable Player Awards. He captured the batting title again in 1940. He kept getting better. In 1941, the finest season of his career, he hit safely in 56 consecutive games, the major-league record. It is often overlooked, but that season, DiMaggio, who made 541 plate appearances, struck out only 13 times.

After hitting .305 in 1942, DiMaggio was drafted. What baseball he played for the next three years was in the U.S. Army.

After DiMaggio returned from military service, his performance slumped. But by 1946, he was back in form, winning his third MVP Award.

In 1949, DiMaggio became baseball's first $100,000 ballplayer and, despite painful injuries, helped the Yankees win the league title. Two years later, DiMaggio retired. He had played on 10 pennant winners and nine world championship teams during his 13-year career.

In the several fielding categories that appear in *The Baseball Encyclopedia*—average, putouts, putouts per game, assists, assists per game, chances, and chances per game—DiMaggio's name appears only once. In putouts per game, he is tied near the bottom of the list with several other players, including his brother Vince. Obviously, statistics can't be used to define DiMaggio's greatness as a center fielder. Instead, one must turn to such people as Casey Stengel, who said to the

DiMaggio camps under a fly ball in spacious center field at Yankee Stadium. *(National Baseball Hall of Fame and Museum)*

media at the time of DiMaggio's retirement: "Joe is far and away the greatest player I have managed. But that is an understatement. I have to explain what I mean by 'greatest.' I mean that he combined qualities which you will not find in the averages."

Support for Stengel's opinion came in 1969, when baseball was celebrating its centennial, and a panel of sportswriters named DiMaggio the "Greatest Living Player." Many of the panelists undoubtedly voted for DiMaggio because of his heroics as a hitter, but surely they also realized that when it came to playing the hitter, getting the jump on the ball, covering ground, and judging fly balls, Joe DiMaggio had few equals.

Pie Traynor

THIRD BASE

Born: November 11, 1899; Framingham,
Massachusetts
Died: March 16, 1972
Height: 6' Weight: 170
Threw right-handed, batted right-handed
Elected to the Hall of Fame in 1948

For nearly half a century, Pie Traynor was considered baseball's greatest third baseman of all time. Although a wave of exceptional third basemen in the past several decades—Mike Schmidt and Brooks Robinson among them—caused Traynor to be dropped a rung or two, he is still rated as one of the very best at the position.

Beginning in 1920, in 17 seasons with the Pittsburgh Pirates, Traynor led the National League in assists three times, in double plays for four consecutive years, in putouts seven times, and established the league record for putouts (since topped by Schmidt). Seven times he was voted baseball's outstanding third baseman by the *Sporting News*. His lifetime .320 batting average is the best for any third baseman in the Hall of Fame.

Harold Traynor's interest in baseball began during his childhood. Too young to be assigned a regular position with a Somerville, Massachusetts, church team, he chased balls in the outfield during batting practice. Afterward, his father would take him to the grocery store for a reward. "I'll take pie,

Father," he would invariably say, a ritual that resulted in his nickname.

When, toward the end of 1920, Pie first joined the Pirates, the club started him at second base. He made 12 errors and batted .212 in the 17 games he played that season. The next year he was back in the minors. Not until 1922 did he take over at third base for the Pirates.

"Nobody taught me how to play third base," Traynor once said. "The way I learned was simply to tackle each situation as it arose and master it before going on to something else. I think I learned more about playing third base in the morning bull sessions in the hotel lobby than I did on the field."

Tall and gangly, Traynor played even with the bag. He had remarkable quickness going to either his right or left. Charlie Grimm, who played first base for the Pirates during the years that Traynor was stationed at third, claimed that Pie often fielded balls down the line bare-handed. "Pie had the quickest hands and the quickest arm of any third baseman," Grimm once told Bob Broeg of the *Sporting*

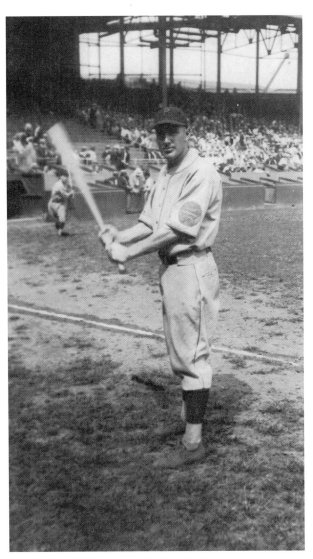

Left: Quick hands and a shotgun arm helped to make Pie Traynor the first of baseball's outstanding third basemen. *(Wide World)*

Below: Traynor in 1927, a season in which he hit .342 and helped lead the Pirates to the National League championship. *(National Baseball Hall of Fame and Museum)*

News. "And from any angle he threw strikes. Playing first base with him was a pleasure if you didn't stop too long to admire the plays he made."

As Pie got older, he continued his mastery at third base, although his style of play changed. "When I was young and had good legs, I could play in closer and take more chances," he said. "But as I grew older and found my reflexes slowing, I found I was second-guessing myself. That's when I started over again, playing back and relying more on positioning."

In 1934, as his playing career was winding down, Traynor was named manager of the Pirates, a post he was to hold for six years. Also in 1934, Traynor injured his throwing arm while sliding home in a game against the Phillies, an injury that helped to hasten his retirement as a player.

After his final season as a manager, Traynor became a Pittsburgh scout. He also served as an instructor for the team during spring training. He ran a sporting goods store in Pittsburgh and was active as a local sportscaster for more than 20 years.

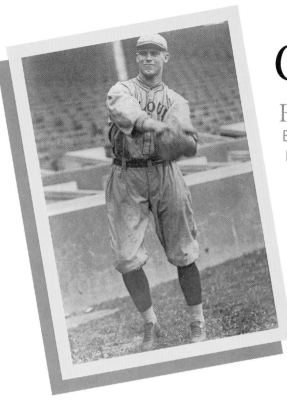

George Sisler

FIRST BASE
Born: March 24, 1893; Manchester, Ohio
Died: March 26, 1973
Height: 5'11" Weight: 170
Threw left-handed, batted left-handed
Elected to the Hall of Fame in 1939

George Sisler believed that to be a standout first baseman, a player needed to have good hands, quick feet and strong legs, and speed in covering the position, particularly when it came to bunts. But most of all, said Sisler, the position required "baseball sense," the ability to anticipate, to realize beforehand what might be going to happen and react accordingly.

Branch Rickey, who managed the St. Louis Browns when Sisler joined the team as a rookie in 1915, delighted in recalling a prime example of Sisler's own baseball sense. The incident occurred on a squeeze-play attempt, with Sisler holding a man at first. Anticipating the play, Sisler charged the plate perfectly, grabbed the ball and tagged the batter before he had hardly left the plate, and then, in the same motion, flipped the ball to the catcher, who tagged the runner sliding in from third for a double play.

Like Hal Chase, another all-time great at first base, Sisler was so agile and quick that he sometimes fielded bunts on the third-base side of the mound, and he could often cut off drives that were

headed into right field for base hits. After Chase retired in 1919, Sisler came to be recognized as the game's premier gloveman at first base. He kept that number-one billing for most of the decade that followed, or until his retirement in 1930.

A college pitching star at the University of Michigan, Sisler joined the Browns following his graduation with a degree in mechanical engineering. Manager Rickey, who had been his college coach, first tried Sisler as a pitcher and an outfielder. Not until 1916, Sisler's first full season as a major leaguer, did Rickey decide to use him at first.

Sisler's consistent bat earned him more headlines than his fancy glovework. He hit .407 in 1920 and .420 in 1922, a season in which he stole 51 bases and hit safely in a record 41 consecutive games. (The record was broken by Joe DiMaggio in 1941.) That year, the Browns almost captured the pennant, losing to the Yankees in an exciting race by just one game. Sisler never again came close to playing in the World Series.

Sisler was undeniably the best player in baseball in 1922. Then he suffered a crushing blow. He

came down with a sinus infection that caused double vision and forced him to sit out the 1923 season. When he returned to the Browns in 1924, he still had double vision. Every baseball he saw looked like two. While he was to have some fine seasons, he never again came close to equaling the performance peaks of his earlier years.

It's interesting to speculate what Sisler might have accomplished had he remained in good health. It's likely that he would be judged as the greatest first baseman of all time. But more than a few observers believe he was, anyway. When Ty Cobb chose his all-star team in a letter to the Hall of Fame, his infield had Sisler at first base (and Eddie Collins at second, Honus Wagner at short, and Buck Weaver at third). Rogers Hornsby

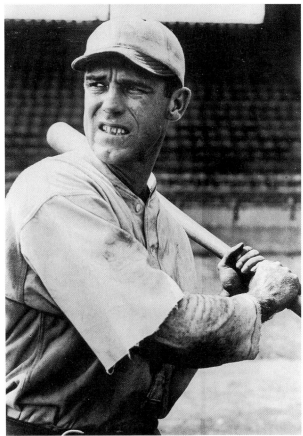

Above: Sisler had a mighty bat, hitting .407 in 1920 and .420 in 1922. *(National Baseball Hall of Fame and Museum)*

Left: Reaching with his pillowy glove, Sisler snags a throw at first base. *(Baseball Nostalgia)*

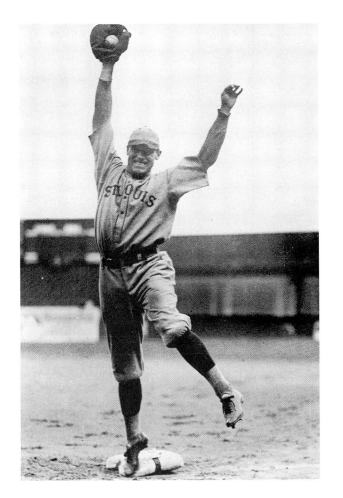

agreed with Cobb, and made Sisler a member of his all-star team. (The other infielders were the same as Cobb's, except for Pie Traynor at third.)

What about Lou Gehrig, the fabled "Iron Horse"? He batted fourth on a Yankee team that is often described as the greatest in baseball history. He had that incredible streak, playing in 2,130 consecutive games. But as a fielder, he was not quite so dominant. Words such as "sure-handed" and "dependable" were often used to describe him. He was never hailed for his artistry as a fielder. George Sisler was.

Tris Speaker

CENTER FIELD
Born: April 4, 1888; Hubbard, Texas
Died: December 8, 1958
Height: 5'11 1/2" Weight: 193
Threw left-handed, batted left-handed
Elected to the Hall of Fame in 1937

A big hitter who could run and throw, Tris Speaker was the first superstar in center field. He set a standard for the position that Kirby Puckett, Willie Mays, Mickey Mantle, Duke Snider, and Joe DiMaggio sought to equal. Not all succeeded.

Speaker played center field extremely shallow, often not more than 20 or 30 feet from second base. He could do this because he played before 1920, in the days of the dead ball, that is. And because he had the speed to get back fast, Speaker played shallower than anyone else.

Speaker also was able to anticipate where the ball was going to be hit. He acquired this skill as a Red Sox rookie in 1907, fielding fly balls hit to him by Cy Young, and trying to determine in advance in which direction the ball was going to go. "In a few days," Speaker said, "I knew just by the way he swung whether the ball would go to my right or left. I began to study the batter during a game; when he started to swing, I knew if the ball would be hit to my right or left, and I was on my way."

Speaker played so shallow he often functioned as a fifth infielder, fielding grounders and throwing

From his post in shallow center field, Speaker would often race in to play the role of a fifth infielder. *(National Baseball Hall of Fame and Library)*

Speaker led American League outfielders seven times in putouts, five times in double plays. *(National Baseball Hall of Fame and Library)*

Traded to Cleveland in 1916, Sisler hit .386 to win the league batting crown. Here he is pictured in 1926, when he managed the team. *(Wide World)*

runners out at first. And he sometimes served as the pivotman on double plays, resulting in such unusual scorecard entries as 6-8-3 (short to center to first) and 4-8-3 (second to center to first).

Speaker executed a record four unassisted double plays, one of them in the 1912 World Series, the only one in Series history. He holds the all-time record with 461 career assists (Willie Mays, by comparison, had 233).

When the dead ball was replaced by the rabbit ball in 1920, Speaker adapted. Although he didn't play as shallow as he once had, he continued to be a dominant figure in center field. He started nine double plays in 1925 and seven in 1926. By way of contrast, five is the greatest number of double plays Kirby Puckett started in a season (in 1991). Speaker also managed to keep his assists and putouts at pre-1920 levels.

While Speaker began his career with the Red Sox and spent nine seasons with the club, he was eventually traded to the Cleveland Indians early in 1916. In his first year with the Indians, Speaker batted .386 to win the league batting crown, breaking Ty Cobb's streak of nine consecutive batting titles.

Doubles were one of Speaker's specialties. He led the league in doubles eight times and ended his career with 792, the all-time record. After a year with the Washington Senators, Speaker ended his career with Philadelphia in 1928.

During more than a few of his 22 years in the majors, Speaker was overshadowed by Ty Cobb. Whatever Speaker did at the plate, Cobb exceeded him. (The 1916 season was an exception.) Speaker's lifetime batting average is .344; Cobb's is .367. Cobb was the better hitter and stole more bases than Speaker. But Speaker wound up on winning teams more often, was an outstanding hitter himself, had a stronger arm, and was the better outfielder.

Hal Chase

FIRST BASE

Born: February 13, 1883; Los Gatos, California
Died: May 18, 1947
Height: 6′ Weight: 175
Threw left-handed, batted right-handed

When Babe Ruth, in his autobiography, *The Babe Ruth Story*, picked the greatest first baseman of all time, he did not choose his teammate Lou Gehrig, nor superstar George Sisler, who Branch Rickey once called "the greatest player who ever lived."

Ruth picked "Prince Hal"—Hal Chase.

Ruth was aware his choice was controversial. Some people, he said, "feel I should pick Lou Gehrig over Chase [but Chase] was so much better than anybody else that I ever saw on first base that—to me—it was no contest."

Within days following his major-league debut with the New York Highlanders (later the Yankees)

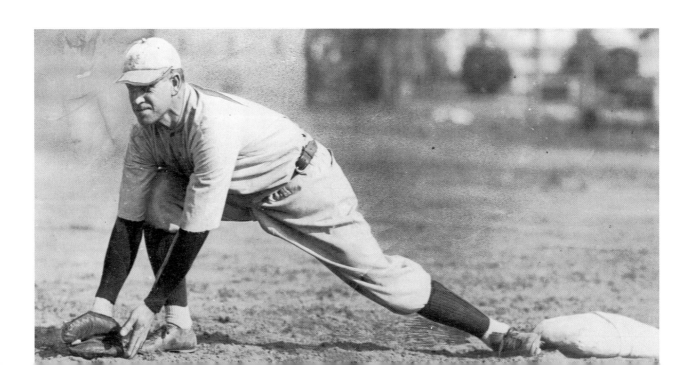

in 1905, Hal Chase was being described as a star. He simply astonished observers of the day. "His range was incredible," writes baseball writer and editor Fred Lieb in his book *Baseball As I Have Known It*. "No other first baseman played so far off the bag. As a man charging a bunt, he was fantastic. He was speed and grace personified."

Chase had been a major leaguer for only two years when the *Sporting News* said of him, ". . . a more brilliant player does not wear a uniform."

Brought up in California, Chase played college baseball at Santa Clara before landing with Los Angeles in the Pacific Coast League in 1904. The next year he was drafted by New York. He remained with the club for nine seasons. In 1910 and 1911, he actually managed the New York team, too. After being dealt to the Chicago White Sox, Chase bounced to Buffalo in the Federal League, then to the Cincinnati Reds, ending his career with the New York Giants in 1919.

Chase was not known only for his fancy work at first base; he was a pretty good hitter, too. In 1915, he led the Federal League in home runs with 17. Five times he batted over .300, and his .339 in 1916 was the National League's best.

Hal Chase is not a member of the Hall of Fame and more than a few baseball observers speak of him in harsh terms. That's because Chase was rather the Pete Rose of his time, leading a career that was tarnished by assorted misdeeds,

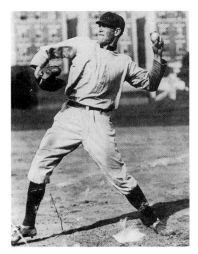

Chase was an artist in gloving grounders to start first-to-second-to-first double plays. *(Wide World)*

although Chase went much further than Rose ever did. What Chase did was conspire to throw games and then bet against his team. He bribed teammates to participate in his schemes and paid bonuses to opposing players to bear down harder. One trick of Chase's was to break late for the base when covering first, letting the ball get by him. Not only did he thereby permit the runner to get on base, but he made it look as if it were the fault of the shortstop or third basemen, who would often be charged with an error.

Charges of dishonesty swirled about Chase almost from the beginning of his career, yet he continued to play the game. Finally, in 1918, when Chase was playing for Cincinnati, manager Christy Mathewson suspended him for violations of National League Rule No. 40, which had to do with "Crookedness and its Penalties."

Chase managed to win an acquittal in the trial that followed but National League president John Heydler later gathered solid evidence to show that Chase had acted to throw a game in 1918. Heydler banned Chase from playing in the National League. In 1921, baseball commissioner Kenesaw Landis prohibited Chase from playing in the American League as well, and Landis made the ban permanent.

Hal Chase was the best defensive first baseman of his time, perhaps of all time. But the many ugly incidents of his career have prevented him from being hailed as one of baseball's great ones.

Left: Chase demonstrates his big stretch at first base. *(National Baseball Hall of Fame and Library)*

Honus Wagner

SHORTSTOP
Born: February 24, 1874; Mansfield,
Pennsylvania
Died: December 6, 1955
Height 5'11" Weight: 200
Threw right-handed, batted right-handed
Elected to the Hall of Fame in 1936

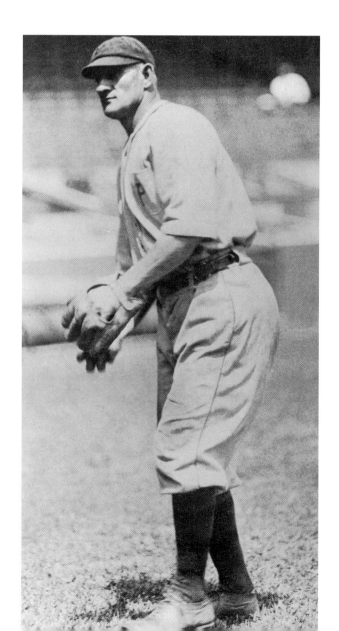

Baseball's first superstar as a fielder was Honus Wagner of the Pittsburgh Pirates, barrel-chested and bowlegged, with wide shoulders and arms so long it was said he could tie his shoes without bending his knees. While he may not have looked exactly like a ballplayer, Wagner was one of the greatest athletes in baseball history and, until more recent times and the arrival of Ozzie Smith, considered to be the finest shortstop ever to play the game.

"He didn't look like a shortstop, you know," Tommy Leach, a teammate of Wagner's, once noted. "He had those huge shoulders and those bowed legs, and he didn't seem to field the balls the way we did. He just ate the ball up with his big hands, like a scoop shovel, and when he threw it to first base, you'd see pebbles and dirt and everything else flying over there with it. It was quite a sight."

To go with his talent for gloving the ball, Wagner had an explosive arm, and probably could have played anywhere. He was an outfield star in the National League for five years and also played

at first, second, and third base. He moved to shortstop on a full-time basis in 1903. It happened that the regular shortstop asked to sit out a game. When Wagner took over, he got a lucky break. With base runners on first and second, he gave the signal for a pickoff play and darted toward second to take the throw. But the pitcher delivered the ball to the plate instead. The batter slammed a one-hopper right to Wagner, who turned it into a double play. Wagner always called it "the best play I ever made."

Wagner captured his first batting title in 1900 and went on to win a total of eight of them, a National League record. His batting average didn't slip below .300 until 1914. He led the league in RBIs four times and in stolen bases five times. When he retired as a player in 1917, he led in hits, runs, singles, doubles, and triples.

Wagner had a Boy Scout attitude about life, believing in clean living and good sportsmanship. Because of his contempt for smoking, he made a tobacco company withdraw from the market a card depicting his portrait that was being sold with their cigarettes. Of the millions of baseball cards available today, Wagner's card, known as "1909-10 T-206," is the most highly prized of all, valued at tens of thousands of dollars.

This surely would have bewildered Wagner himself, who never sought the spotlight. He was always kind and gentle, eager to help rookies, patient with the fans, ever cheerful, undoubtedly the most beloved player of his day.

In the book *The Glory of Their Times*, Paul Waner told Lawrence Ritter: "I did see Honus

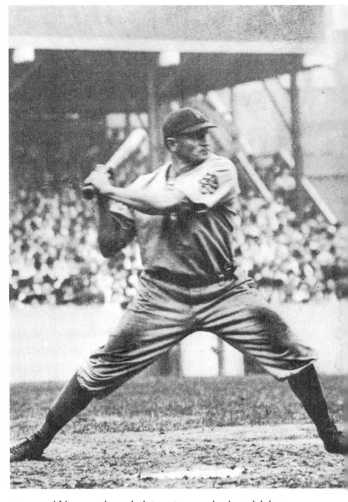

Above: Wagner's mighty stance helped him win eight batting titles. *(Baseball Nostalgia)*

Above left: No baseball card is as valuable as Wagner's T-206 cigarette card. *(Baseball Nostalgia)*

Left: Although Wagner didn't look very much like a shortstop, he was considered the best ever at the position until fairly recent times. *(National Baseball Hall of Fame and Library)*

Wagner play, I really did. Honus came back as a coach with the Pirates during the 'thirties. He must have been sixty years old easy, but goldarned if that old boy didn't get out there at shortstop every once in a while during fielding practice and play that position. When he did that, a hush would come over the whole ball park, and every player on both teams would just stand there, like a bunch of kids, and watch every move he made. I'll never forget it."

Nap Lajoie

SECOND BASE

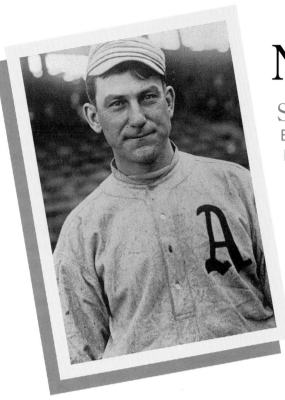

Born: September 5, 1874; Woonsocket, Rhode Island
Died: February 7, 1959
Height: 6'1" Weight: 195
Threw right-handed, batted right-handed
Elected to the Hall of Fame in 1937

Nap Lajoie (pronounced Lah-joe-way) was an outfielder early in his career and finished as a first baseman, but it is as a second baseman that he is remembered. No other player at the position performed so brilliantly for so long a time (21 years).

Charles F. Faber, in his book, *Baseball Ratings*, concluded that Lajoie was not merely the game's greatest second baseman but the greatest player of all time, and it wasn't even close. Faber's top five are: Lajoie, 3,196 points; Babe Ruth, 2,869; Ty Cobb, 2,853; Honus Wagner, 2,842; and Tris Speaker, 2,638.

Faber's rating system surely must take into account that Lajoie hit .422 in 1901, a mark that Cobb, with a lifetime average of .367, never equaled. And Lajoie won a Triple Crown and four batting titles, had 3,242 career hits, and a lifetime average of .338.

Lajoie also had plenty of accomplishments in the field. Smooth and elegant, he made tough plays look easy. "Most graceful" are the words used to describe him on his Hall of Fame plaque.

He was the first second baseman to be elected to the Hall of Fame.

Lajoie had a textbook view about playing second base. On positioning himself in the field, he said, "I play deep field and change my distance from the base according to the style of pitching. You must size up the man at bat and know the style of ball the pitcher is to feed him."

On completing double plays, Lajoie advised, "In turning to throw, step in front of the base and throw regardless of the man coming down, as he will generally look out for himself and is not anxious to get hit with the ball."

On taking fly balls, Lajoie noted, "A second baseman should go for short flies and depend on the outfielders for coaching, for they are in a better position to judge the ball."

Such observations are as valid today as they were a century ago when Lajoie was about to launch his major-league career. The youngest of eight children of French-Canadian parents, Lajoie signed his first contract with Fall River of the New

England League in 1896. He was a star from the beginning, batting .429. After only three months of minor-league experience, his contract was purchased by the Philadelphia Phillies. Within a year, Lajoie had established himself as one of the game's leading hitters.

In 1901, after Lajoie had switched to the Philadelphia Athletics, he won the league's first batting championship, compiling his .422, still the league record. In 1903 and 1904, with Cleveland, Lajoie hit .355 and .381.

Lajoie was popular with his teammates, opposing players, and the fans. In 1905, after he was named Cleveland's player-manager, the team was actually renamed the Naps in his honor, a rare tribute, and one never enjoyed by Ruth, Cobb, Wagner, or Speaker. Faber's *Baseball Ratings* must have taken that into consideration, too.

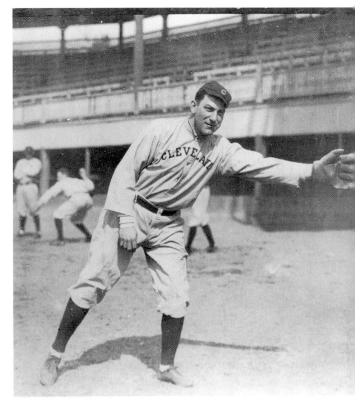

Above: Lajoie displays the glove that he wore as one of the game's great second basemen. *(Wide World)*

Left: On Lajoie's Hall of Fame plaque, "most graceful" are the words used to describe him as a fielder. *(National Baseball Hall of Fame and Library)*

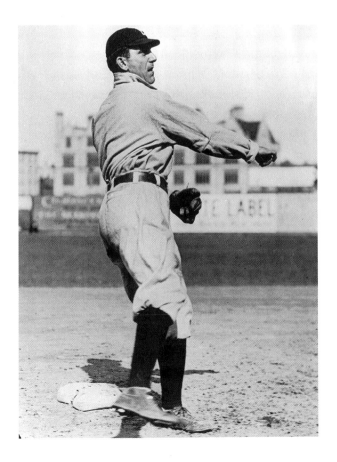

Fielding Averages and Gold Glove Awards

Of the many statistical categories used to rate defensive players, fielding average is usually considered to be the most significant. It reports on how close each player comes to perfection, or 1.000. Fielding averages are almost always well above .950.

One's fielding average is figured by adding the player's putouts, assists, and errors to get his total chances. The number of total chances is then divided into the sum of putouts and assists, and the result is carried out to three decimal places.

Here's an example in which the number of total chances is 529 and the sum of putouts and assists is 523. (The player, obviously, had six errors.)

$$
\begin{array}{r}
.989 \\
529{\overline{\smash{\big)}\,523.000}} \\
\underline{4761} \\
4690 \\
\underline{4232} \\
4580 \\
\underline{4232} \\
348
\end{array}
$$

The player's fielding average is .989.

The Gold Glove Award to recognize fielding excellence was established by the Rawlings Sporting Goods Company in 1957. That year Rawlings merely honored each of the nine major-league players chosen for the *Sporting News* All-Star Fielding Team.

The following year, 1958, the major-league players made the selections, choosing an "All-Star Fielding Team" for each league. An individual Gold Glove was presented to each of the 18 players.

Major-league managers and coaches have been doing the selecting since 1965. Those voting are not permitted to choose players from their own teams.

The award itself consists of a metal cast of a leather glove finished in gold, and mounted on a trophy stand. Each winner's trophy exhibits the type of glove that is consistent with the position he plays.

FIELDING AVERAGES

First Base
1 Steve Garvey .996
2 Wes Parker .996
3 Don Mattingly .996
4 Don Driessen .995
5 Jim Spencer .995
6 Frank McCormick .995
7 Keith Hernandez .994
8 Vic Power .994
9 Joe Adcock .994
10 Kent Hrbek .994

Second Base
1 Ryne Sandberg .990
2 Tommy Herr .989
3 Jim Gantner .985
4 Lou Whitaker .984
5 Frank White .984
6 Bobby Grich .984
7 Jerry Lumpe .984
8 Cookie Rojas .984
9 Dave Cash .984
10 Nellie Fox .984

Outfield
1 Terry Puhl .993
2 Brett Butler .992
3 Pete Rose .991
4 Amos Otis .991
5 Joe Rudi .991
6 Mickey Stanley .991
7 Jimmy Piersall .990
8 Robin Yount .990
9 Jim Landis .989
10 Ken Berry .989

Third Base
1 Brooks Robinson .971
2 Ken Reitz .970
3 George Kell .969
4 Don Money .968
5 Steve Buechele .968
6 Don Wert .968
7 Willie Kamm .967
8 Heinie Groh .967
9 Carney Lansford .966
10 Clete Boyer .965

Shortstop
1 Tony Fernandez .980
2 Larry Bowa .980
3 Ozzie Smith .978
4 Cal Ripken .978
5 Spike Owen .978
6 Alan Trammell .977
7 Mark Belanger .977
8 Dick Schofield .977
9 Bucky Dent .976
10 Roger Metzger .976

Pitcher
1 Don Mossi .990
2 Gary Nolan .990
3 Rick Rhoden .989
4 Lon Warneke .988
5 Jim Wilson .988
6 Woodie Fryman .988
7 Larry Gura .986
8 Grover Alexander .985
9 General Crowder .984
10 Bill Monbouquette .984

Catcher

1	Bill Freehan	.993
2	Elston Howard	.993
3	Jim Sundberg	.993
4	Sherm Lollar	.992
5	Tom Haller	.992
6	Johnny Edwards	.992
7	Lance Parrish	.991
8	Jerry Grote	.991
9	Ernie Whitt	.991
10	Gary Carter	.991

GOLD GLOVE AWARDS
AMERICAN LEAGUE

Pitcher
Jim Kaat	14
Mark Langston	7
Ron Guidry	5
Jim Palmer	4
Bobby Shantz	3
Mike Norris	2
Frank Lary	1
Bret Saberhagen	1
Mike Boddicker	1

Catcher
Jim Sundberg	6
Bill Freehan	5
Bob Boone	5
Ivan Rodriguez	4
Earl Battey	3
Thurman Munson	3
Lance Parrish	3
Sherm Lollar	3
Ray Fosse	2
Elston Howard	2
Carlton Fisk	1
Sandy Alomar, Jr.	1
Tony Peña	1

First Base
Don Mattingly	9
George Scott	8
Vic Power	7
Joe Pepitone	3
Eddie Murray	3
Jim Spencer	2
Cecil Cooper	2
Mike Squires	1
Chris Chambliss	1
Mark McGwire	1
J. T. Snow	1

Second Base
Frank White	8
Bobby Richardson	5
Roberto Alomar	5
Bobby Grich	4
Bobby Knoop	3
Davey Johnson	3
Lou Whitaker	3
Nellie Fox	3
Harold Reynolds	3
Doug Griffin	2
Frank Bolling	1

Shortstop
Luis Aparicio	9
Mark Belanger	8
Alan Trammell	4
Tony Fernandez	4
Omar Vizquel	3
Zoilo Versalles	2
Cal Ripken, Jr.	2
Ed Brinkman	1
Rick Burleson	1
Jim Fregosi	1
Robin Yount	1
Alfredo Griffin	1
Ozzie Guillen	1

Third Base
Brooks Robinson	16
Buddy Bell	6
Gary Gaetti	4
Robin Ventura	3
Frank Malzone	3
Graig Nettles	2
Wade Boggs	2
Aurelio Rodriguez	1
George Brett	1
Kelly Gruber	1

Outfield

Al Kaline	10		Sixto Lezcano	1
Dwight Evans	8		Jackie Jensen	1
Paul Blair	8		Roger Maris	1
Carl Yastrzemski	7		Vic Davalillo	1
Devon White	7			
Dwayne Murphy	6		Tony Oliva	1
Kirby Puckett	6		Reggie Smith	1
Ken Griffey, Jr.	6		Rick Manning	1
Dave Winfield	5		Al Cowens	1
Gary Pettis	5		Rick Miller	1
Fred Lynn	4		Willie Wilson	1
Jim Landis	4		Rickey Henderson	1
Mickey Stanley	4		Ellis Burks	1
Joe Rudi	3			
Amos Otis	3			
Minnie Minoso	3			
Kenny Lofton	3			
Jimmy Piersall	2			
Ken Berry	2			
Jesse Barfield	2			
Norm Siebern	1			
Juan Beniquez	1			
Mickey Mantle	1			
Tom Tresh	1			
Tommy Agee	1			
Bobby Murcer	1			

NATIONAL LEAGUE

Pitcher

Bob Gibson	9
Greg Maddux	6
Phil Niekro	5
Bobby Shantz	4
Harvey Haddix	3
Andy Messersmith	2
Jim Kaat	2
Rick Reuschel	2
Steve Carlton	1
Fernando Valenzuela	1
Joaquin Andujar	1
Orel Hershiser	1
Ron Darling	1

First Base

Keith Hernandez	11
Bill White	7
Wes Parker	6
Steve Garvey	4
Gil Hodges	3
Mark Grace	3
Andres Galarraga	2
Mike Jorgenson	1
Will Clark	1
Jeff Bagwell	1

Catcher

Johnny Bench	10
Del Crandall	4
Gary Carter	3
Tony Peña	3
Benito Santiago	3
Tom Pagnozzi	3
John Roseboro	2
Johnny Edwards	2
Bob Boone	2
Joe Torre	1
Randy Hundley	1
Jody Davis	1
Mike LaValliere	1
Kirt Manwaring	1
Charles Johnson	1

Second Base

Ryne Sandberg	9
Bill Mazeroski	8
Joe Morgan	5
Manny Trillo	3
Felix Millan	2
Tommy Helms	2
Craig Biggio	2
Charlie Neal	1
Ken Hubbs	1
Glen Beckert	1
Davey Lopes	1
Doug Flynn	1
José Lind	1
Robby Thompson	1

Shortstop

Ozzie Smith	13
Dave Concepción	5
Roy McMillan	3
Don Kessinger	2
Gene Alley	2
Maury Wills	2
Larry Bowa	2
Barry Larkin	2
Ernie Banks	1
Bobby Wine	1
Rubén Amaro	1
Leo Cárdenas	1
Dal Maxvill	1
Bud Harrelson	1
Roger Metzger	1
Jay Bell	1

Third Base

Mike Schmidt	10
Ken Boyer	6
Ron Santo	5
Doug Rader	5
Terry Pendleton	3
Matt Williams	3
Tim Wallach	2
Jim Davenport	1
Ken Reitz	1
Ken Caminiti	1

Outfield

Roberto Clemente	12		
Willie Mays	12		
Garry Maddox	8		
André Dawson	8		
Curt Flood	7		
Dale Murphy	5		
César Cedeno	5		
Tony Gwynn	5		
Andy Van Slyke	5		
Barry Bonds	5		
César Geronimo	4		
Bobby Bonds	3		
Hank Aaron	3		
Willie Davis	3		
Willie McGee	3		
Dave Parker	3		
Marquis Grissom	3		
Dave Winfield	2		
Pete Rose	2		
Larry Walker	2		
Vada Pinson	1		
Bill Virdon	1		
Dusty Baker	1		
Tommy Agee	1		
Wally Moon	1		

Jackie Brandt	1
Ellis Valentine	1
Frank Robinson	1
Bob Dernier	1
Darren Lewis	1
Raul Mondesi	1
Steve Finley	1